North Carolina

impressions

Photography by **Jim Hargan** and **Laurence Parent**

FARCOUNTRY
PRESS

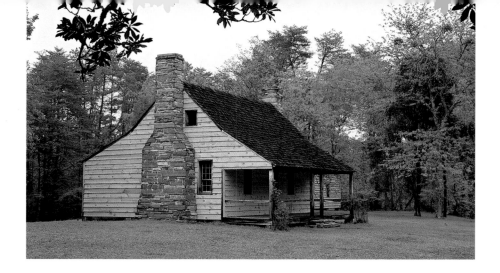

ABOVE: Tucked at the foot of Fall Mountain in 4,472-acre Morrow Mountain State Park, the homestead of Dr. Francis Joseph Kron—the first doctor in the southern piedmont of North Carolina—was restored in the 1960s to look as it did in the 1870s. LAURENCE PARENT

RIGHT: At the University of North Carolina at Asheville, flowering dogwoods grace the ten-acre botanical gardens devoted to the state's native plants. JIM HARGAN

TITLE PAGE: The creamy blossoms of flowering dogwood, North Carolina's state flower, are a herald of spring. JIM HARGAN

FRONT COVER: Rhododendrons in bloom at Reinhart Knob, along the Blue Ridge Parkway. JIM HARGAN

BACK COVER: The seventy-five-foot solid brick Ocracoke Lighthouse, located in the seventy-mile-long Cape Hatteras National Seashore, was built in 1823 for a cost of $11,359. LAURENCE PARENT

ISBN 13: 978-1-56037-345-2
ISBN 10: 1-56037-345-8
Photography © 2006 Jim Hargan and Laurence Parent
© 2006 Farcountry Press

For more information about our books write Farcountry Press, P.O. Box 5630,
Helena, MT 59604; call (800) 821-3874; or visit www.farcountrypress.com.

Created, produced, and designed in the United States.
Printed in China.

10 09 08 07 06 1 2 3 4 5

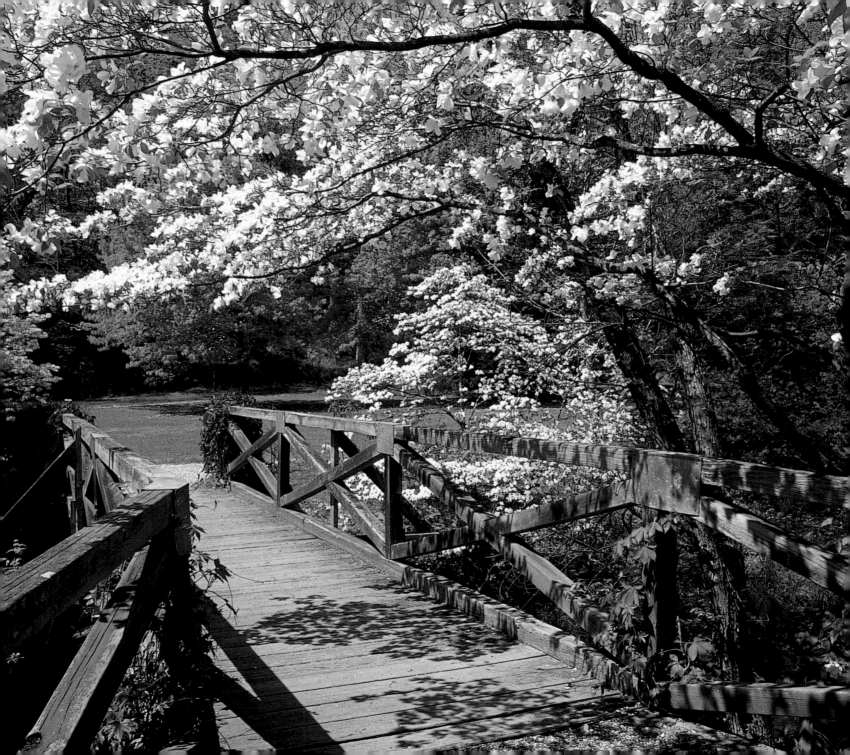

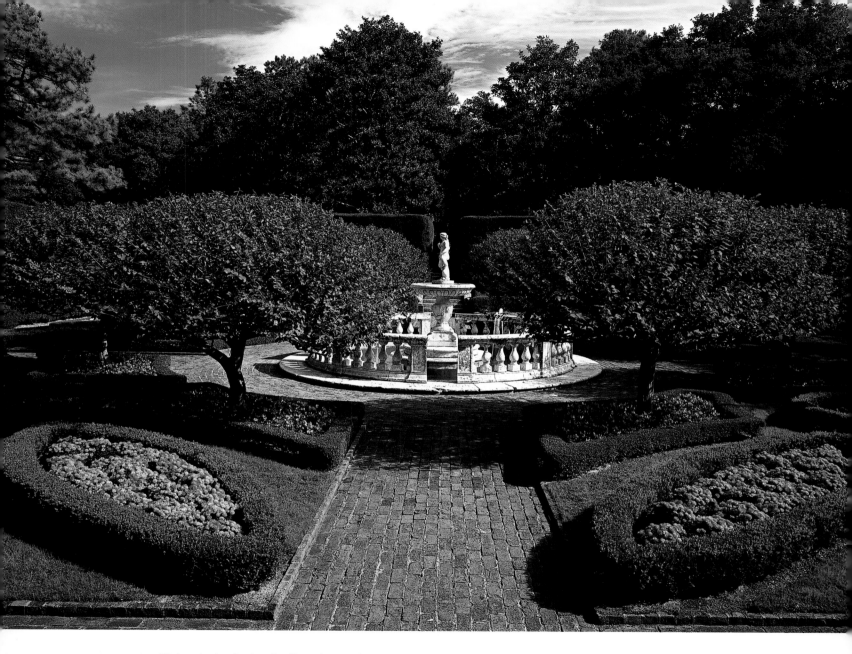

ABOVE: With its beds of red and yellow chrysanthemums, clipped yaupon hedges, and an antique Italian fountain, the Sunken Garden is part of the Elizabethan Garden. Located in the Outer Banks, the Elizabethan Garden opened in 1960 on the site of the New World's first English colony and features more than 500 plant species. LAURENCE PARENT

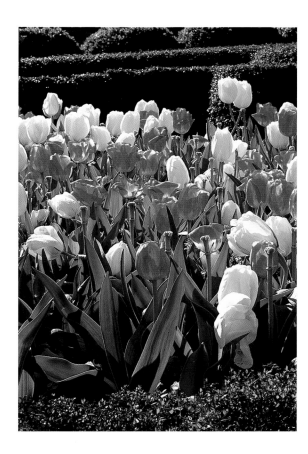

ABOVE: Flame azalea and mountain laurel along the Craggy Pinnacle Trail, a 1.4-mile hike that offers 360-degree views of the Blue Ridge Parkway.
JIM HARGAN

RIGHT: Red and white tulips adorn the fourteen-acre gardens of Tryon Palace, the first residence of Royal Governor William Tryon from 1767 to 1770, when New Bern was the capital of the colony of North Carolina.
JIM HARGAN

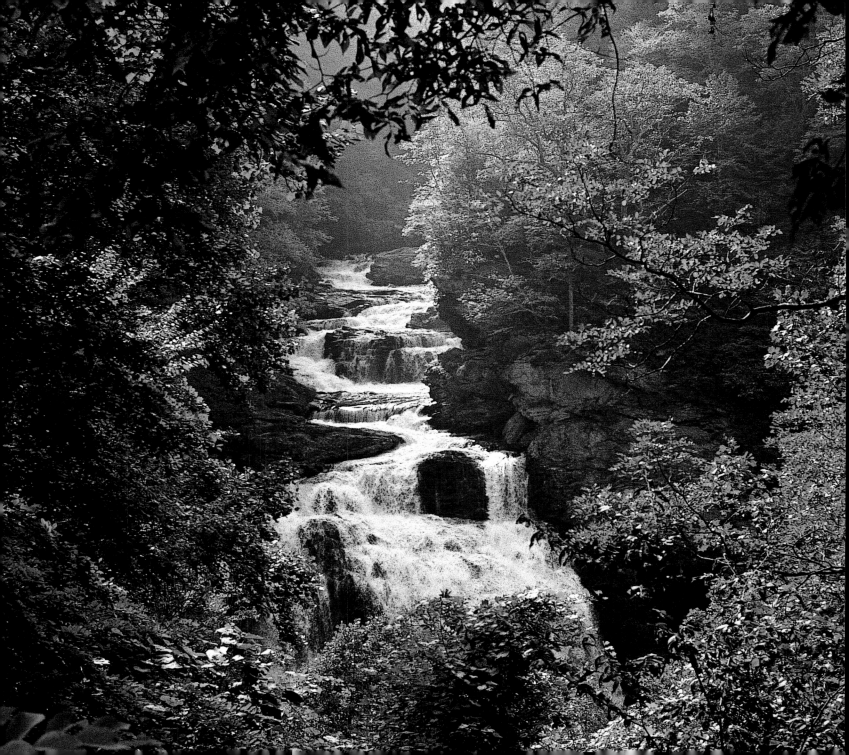

LEFT: Water cascades 250 feet over Cullasaja Falls in the Nantahala National Forest in Macon County. JIM HARGAN

BELOW: The dramatic thirty-foot drop created by the Sequoyah Lake Dam in the Highlands area of the Blue Ridge Mountains. JIM HARGAN

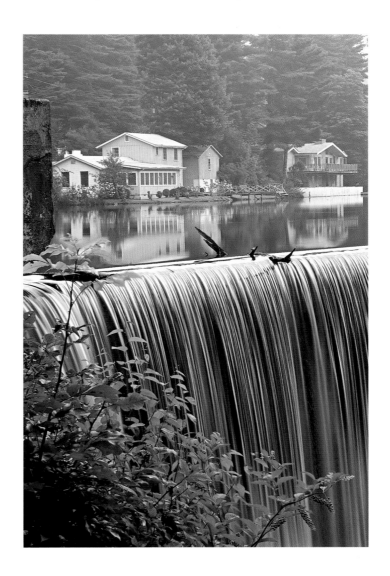

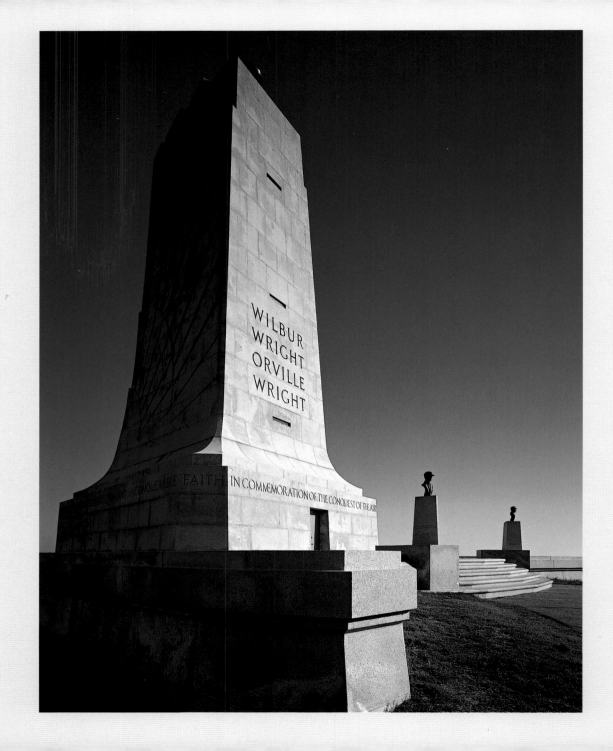

FACING PAGE: This sixty-foot-tall monument at the Wright Brothers National Memorial on Kill Devil Hill commemorates the first successful flight in a heavier-than-air machine made by Wilbur and Orville Wright on December 17, 1903. LAURENCE PARENT

BELOW: The U.S.S. *North Carolina*, located in Wilmington, offers tours of the nine decks, gun turrets, and crew quarters of the battleship that fought in the Pacific theater in World War II. JIM HARGAN

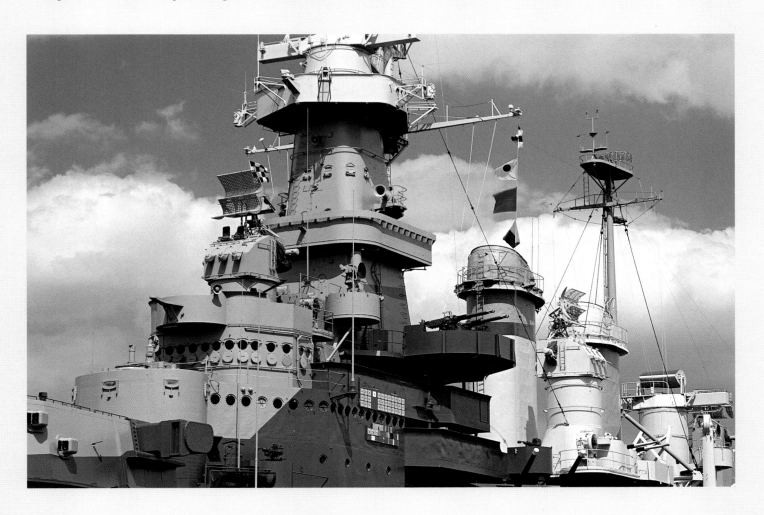

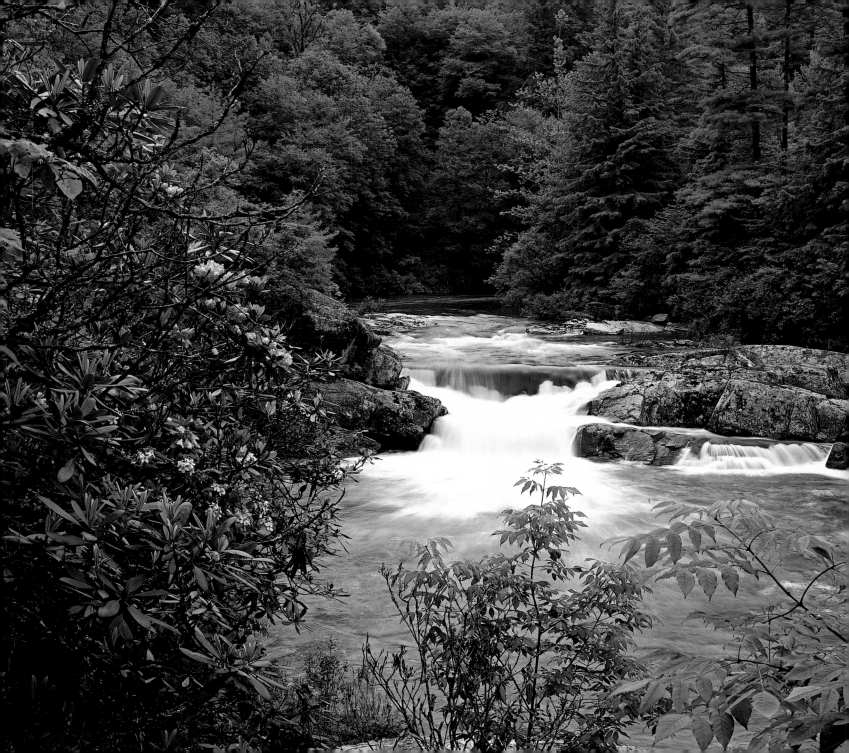

LEFT: Carolina rhododendrons edge the upper cascades of Linville Falls along the Blue Ridge Parkway. Surrounded by white pine and hemlock, the falls drop ninety feet to a twelve-mile-long gorge. LAURENCE PARENT

BELOW: Water streams down the boulders of Glen Falls in the Nantahala National Forest. Three waterfalls make up Glen Falls, each with a sixty-foot drop. LAURENCE PARENT

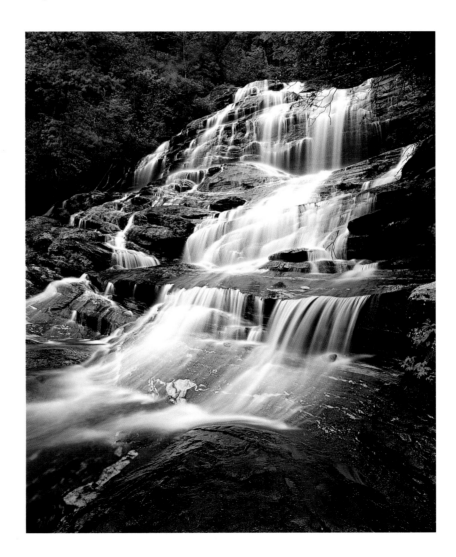

RIGHT: In Swain County in the Great Smoky Mountains, a red barn stands out against the snow-covered fields near the Conley Creek community. JIM HARGAN

BELOW: A horse nibbles snow at the Mountain Farm Museum in Great Smoky Mountains National Park, where visitors can witness the lifestyles of the pioneers that settled this area in the late 1700s. JIM HARGAN

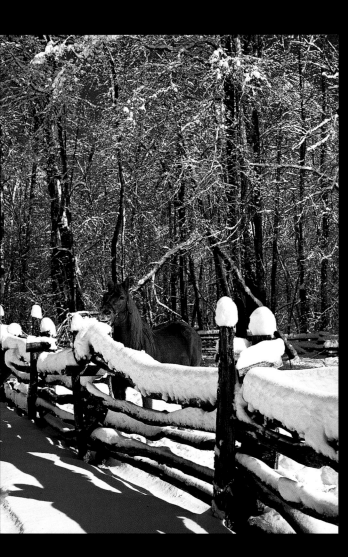

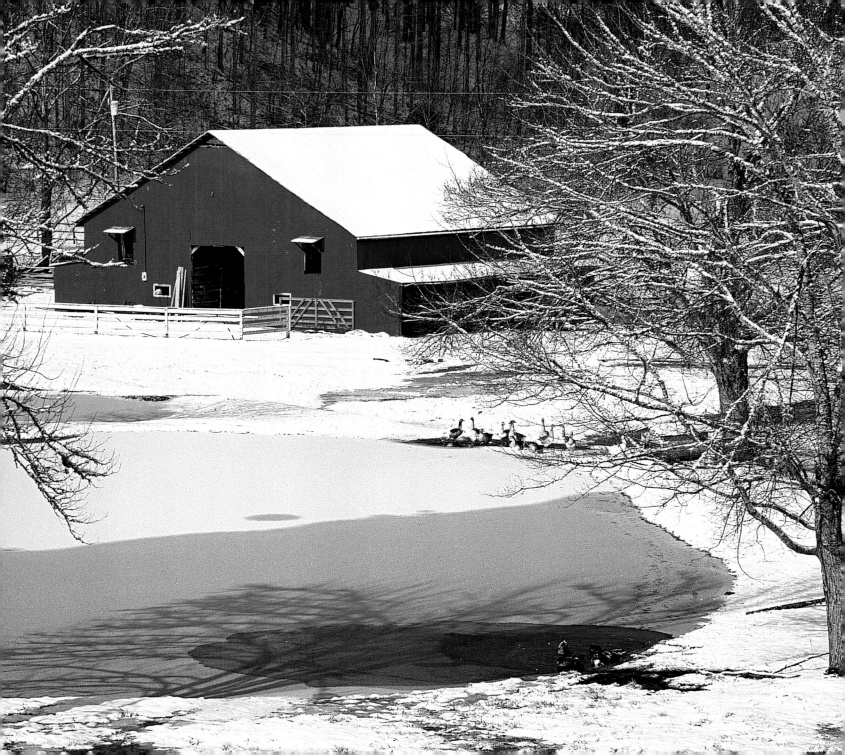

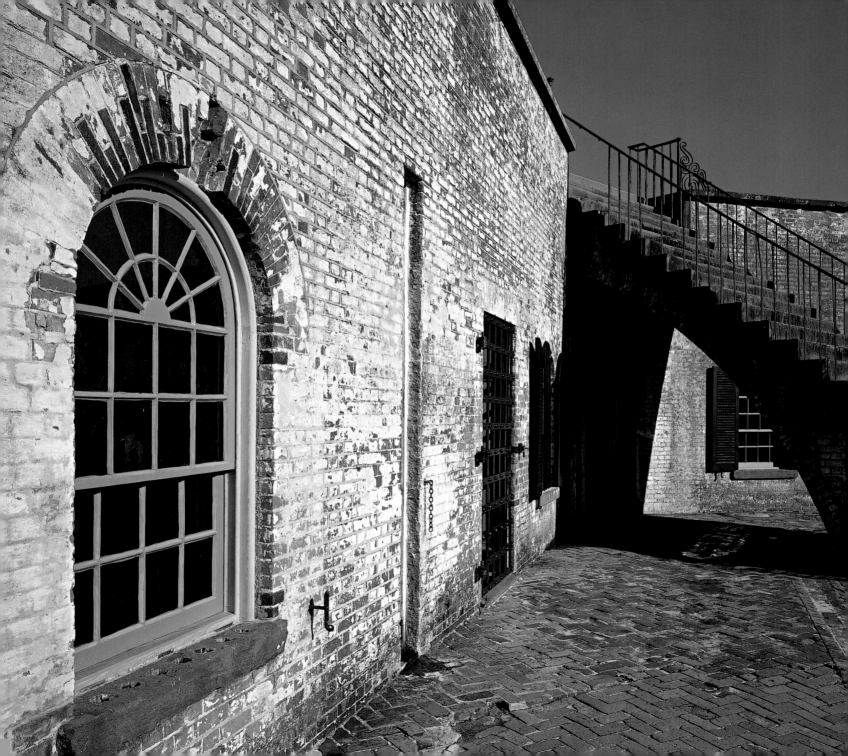

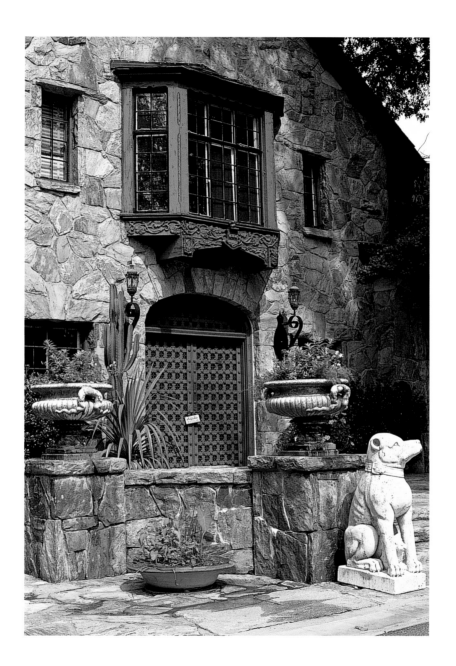

LEFT: The ornate entrance to Thomas Jefferson Penn's twenty-seven-room stone mansion on the 1920s-era Chinqua-Penn Plantation, which now features twenty-two acres of historic gardens. JIM HARGAN

FAR LEFT: Located in a 385-acre state park east of Atlantic Beach, the five-sided, brick Fort Macon was built from 1826 to 1834. It was seized by the Confederate Army and recaptured by Union forces during the Civil War. LAURENCE PARENT

RIGHT: The showy pink Catawba rhododendron adorns the entrance of the 176-foot-long Craggy Pinnacle Tunnel in the Blue Ridge Parkway. JIM HARGAN

BELOW: These delicate pink showy orchids are just one of nearly 1,400 flowering plant species that thrive in Great Smoky Mountains National Park. LAURENCE PARENT

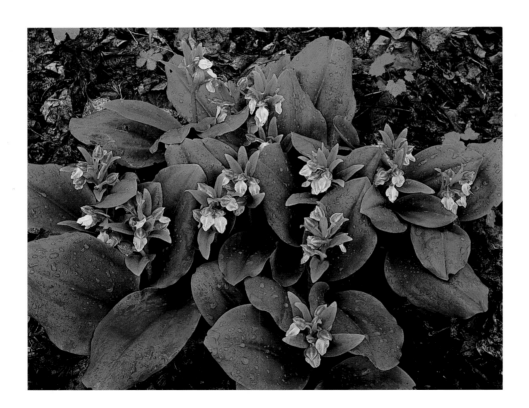

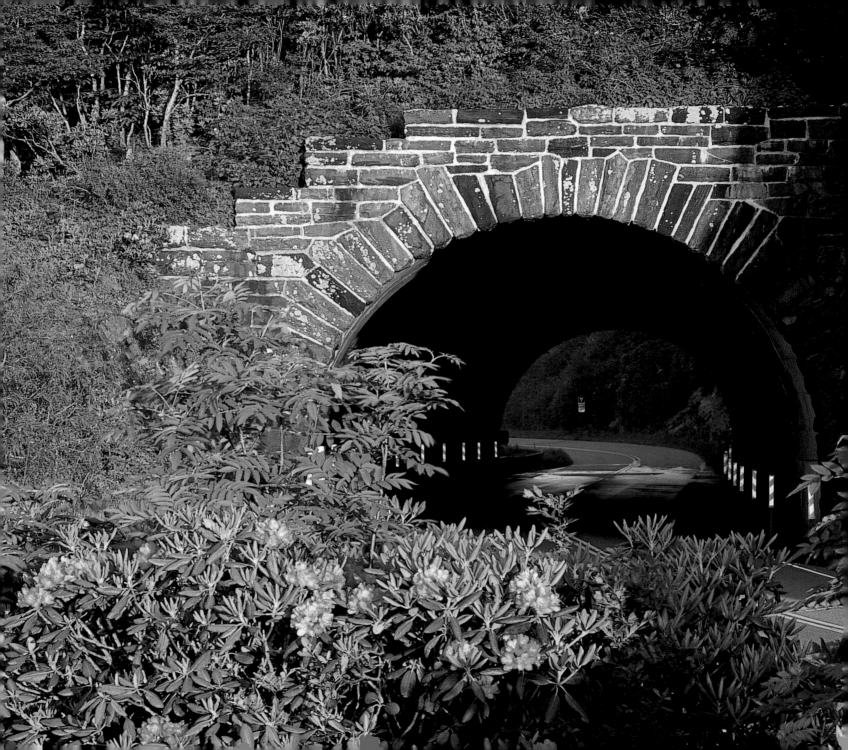

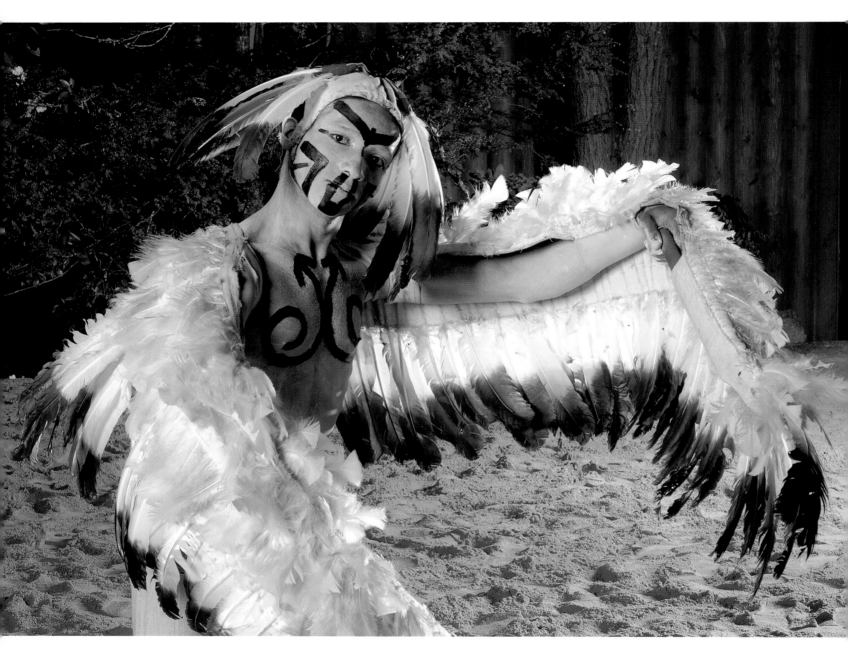

FACING PAGE AND RIGHT: The eagle dancer in *Unto These Hills*, a play about the history and traditions of the Cherokee Nation that debuted in 1950, performed in the outdoor Mountainside Theatre in Cherokee.
PHOTO COURTESY OF THE EASTERN BAND OF CHEROKEE INDIANS

BELOW: This craftsman demonstrates arrowhead napping in the Oconaluftee Indian Village, a recreation of a 1750s Cherokee village. Using a small stone, he shapes the arrowhead, then he sharpens it by applying pressure to the arrowhead's edges with a deer's antler.
PHOTO COURTESY OF THE EASTERN BAND OF CHEROKEE INDIANS

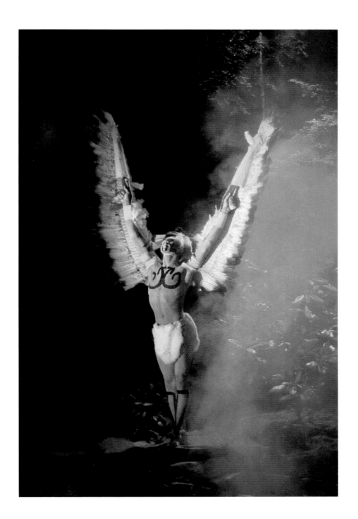

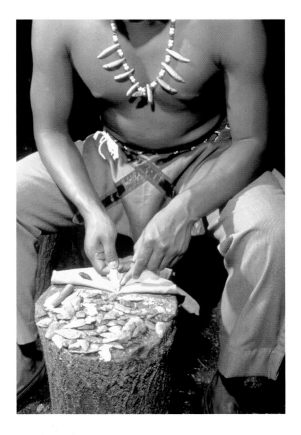

RIGHT: Little Santeetlah Creek ripples through the dense old-growth forest in Joyce Kilmer–Slickrock Wilderness, a 3,840-acre preserve that was created in 1975. Kilmer was the author of the famous poem "Trees." LAURENCE PARENT

BELOW: Old-growth hemlock trees flourish near Linville Falls, a dramatic sequence of waterfalls along the Blue Ridge Parkway. LAURENCE PARENT

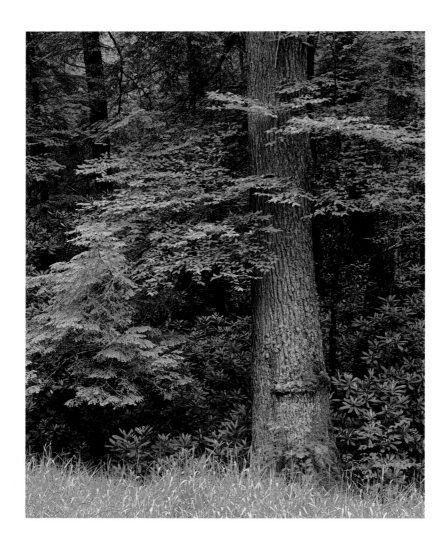

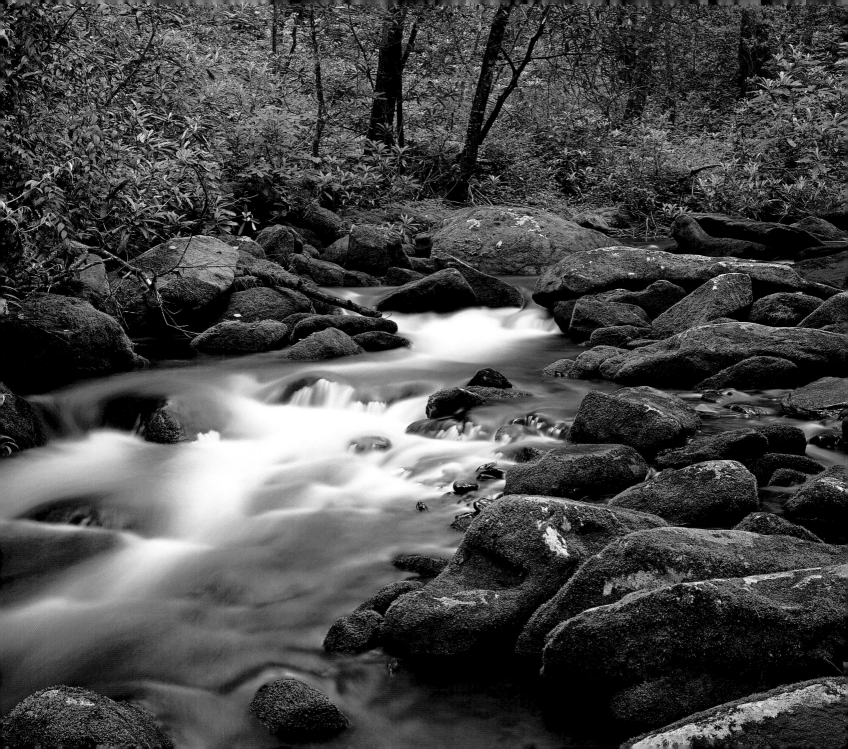

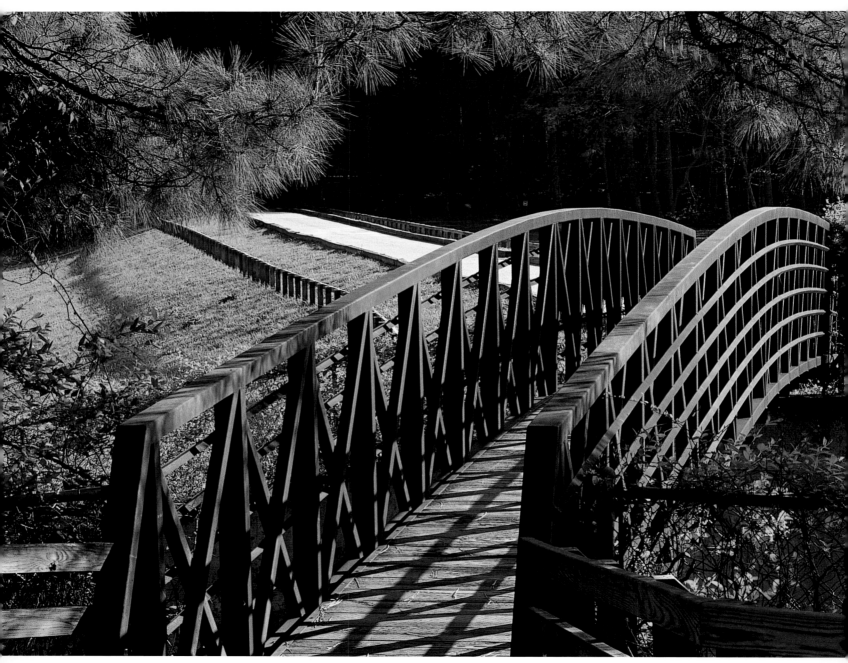

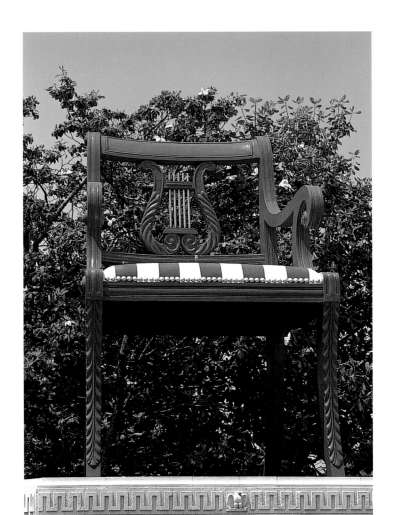

LEFT: The Big Chair, the world's largest chair, is 30 feet high and has a seat that is 10.5 feet wide. Designed to replicate a Duncan Phyfe armchair, this chair was built in 1952 to celebrate the town's primary business, the Thomasville Chair Company. JIM HARGAN

FAR LEFT: A simple yet elegant footbridge in William B. Umstead State Park, a peaceful haven tucked between Raleigh, Cary, and Durham. JIM HARGAN

RIGHT: The Old Mill of Guilford, built in 1767 and listed on the National Register of Historic Places, is also a working mill where owner Charlie Parnell processes grains and corn. JIM HARGAN

BELOW: The waters of Bridal Veil Falls descend 120 feet alongside the road in Nantahala National Forest, moistening visitors and vehicles alike. LAURENCE PARENT

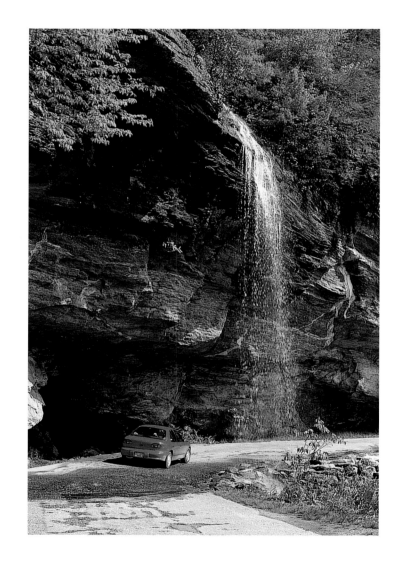

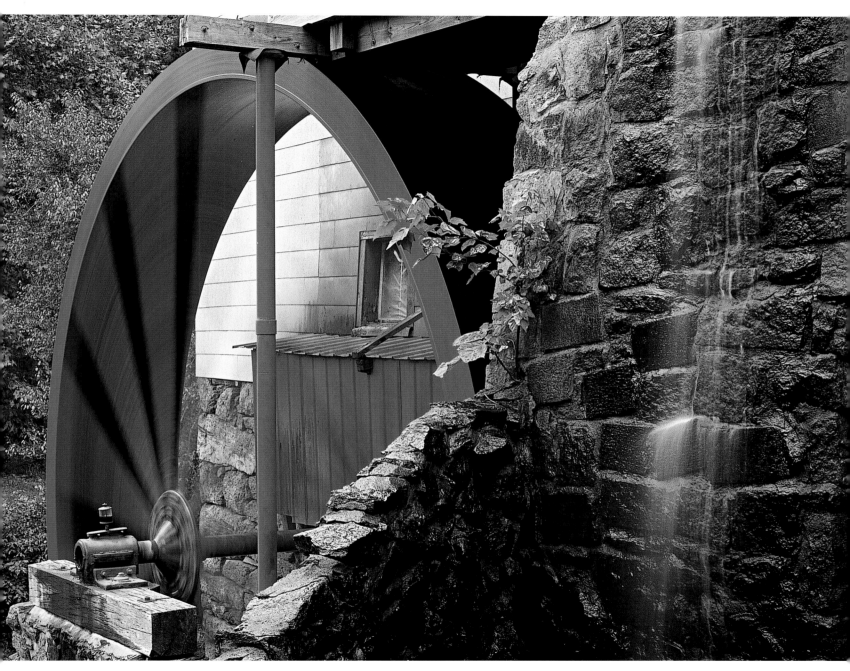

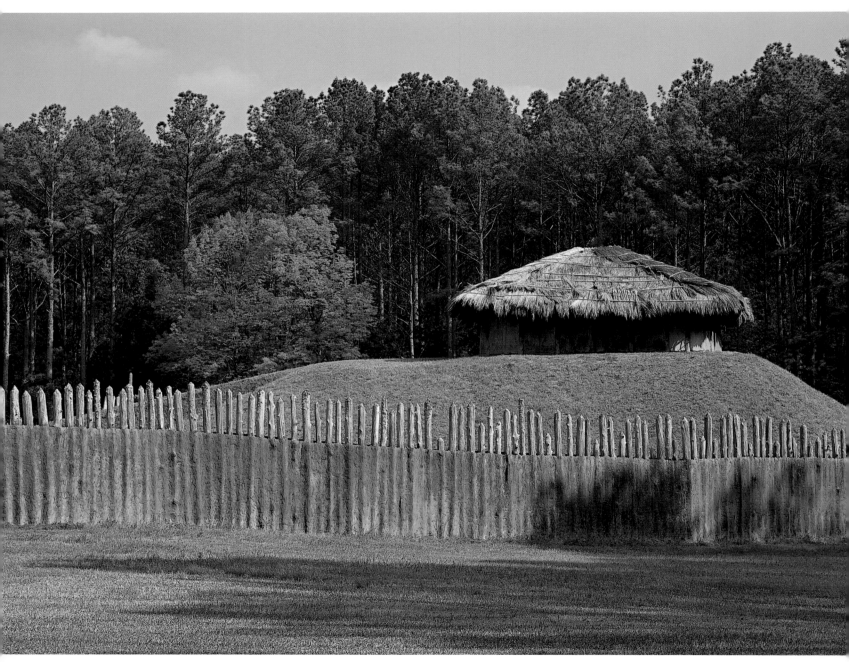

FACING PAGE: This earthen mound, located in the Town Creek Indian Mound State Historic Site, was built by twelfth-century Indians who lived an agricultural life. LAURENCE PARENT

BELOW: A wild horse grazing on a salt marsh near the Beaufort waterfront on Carrot Island, one of a string of small islands in the Rachel Carson National Estuarine Research Reserve. JIM HARGAN

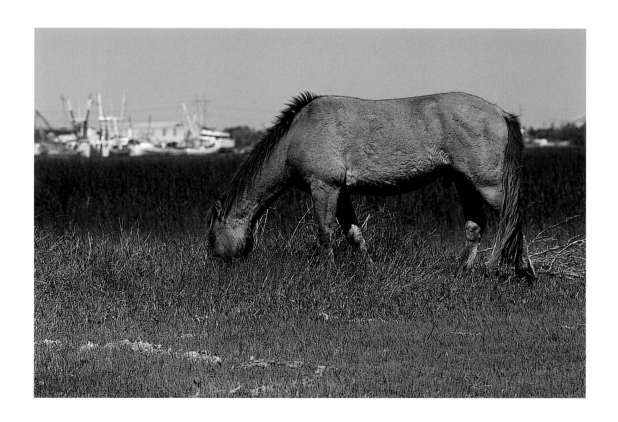

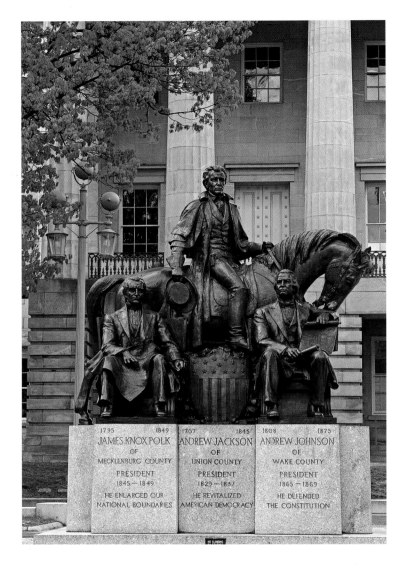

ABOVE: Set in front of the 1833 capitol in Raleigh, the "Three Presidents" statue, as it is known, honors Andrew Jackson, James Knox Polk, and Andrew Johnson—all three were North Carolina residents who became U.S. presidents. JIM HARGAN

RIGHT: Built at an elevation of 5,305 feet, the Mile High Swinging Bridge at Grandfather Mountain was built in 1952 to provide visitors with breathtaking views of Grandfather Mountain's Linville Peak. JIM HARGAN

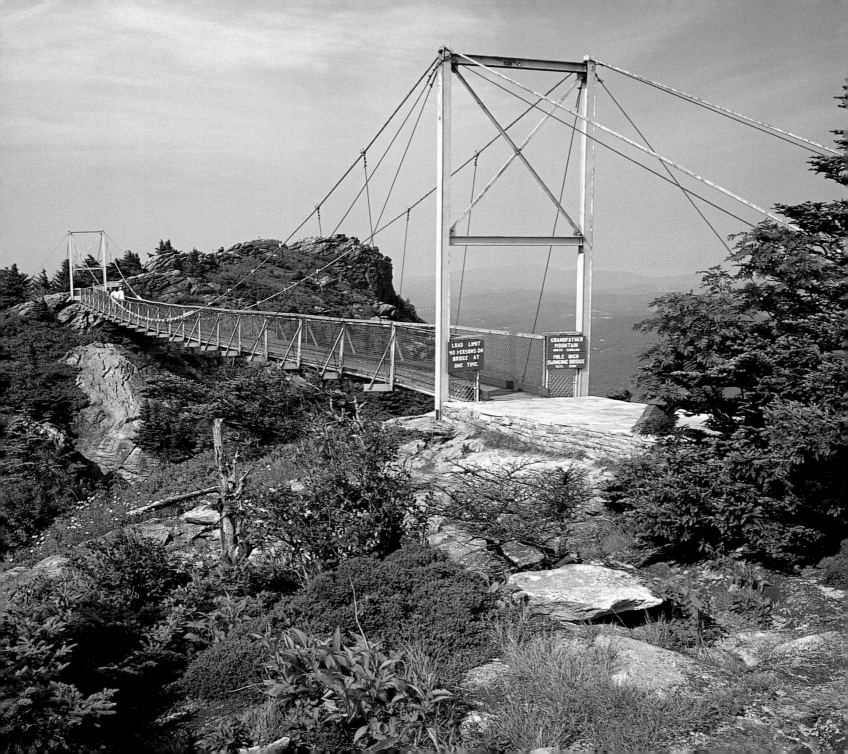

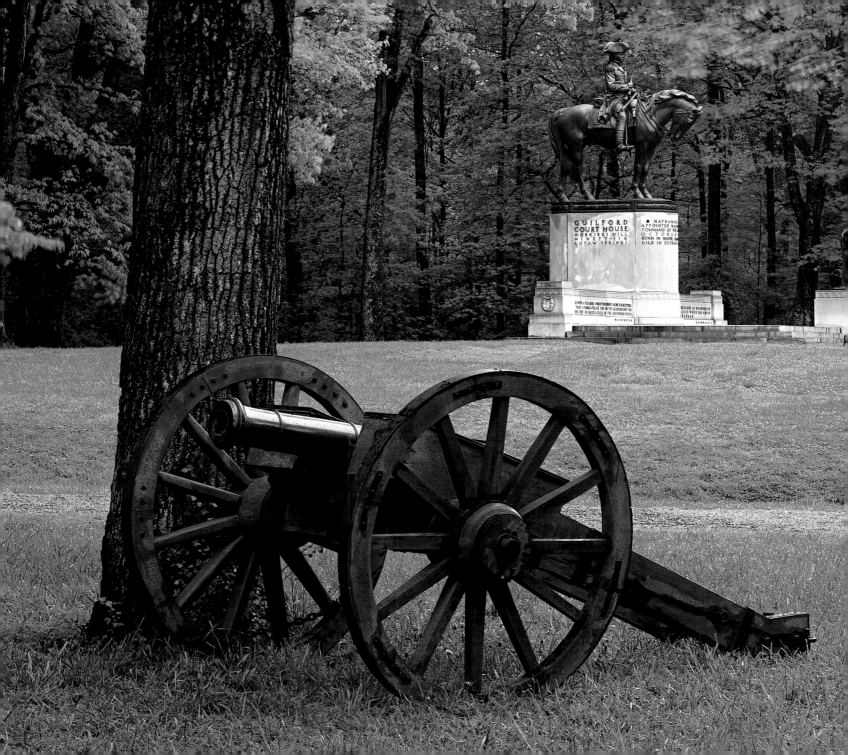

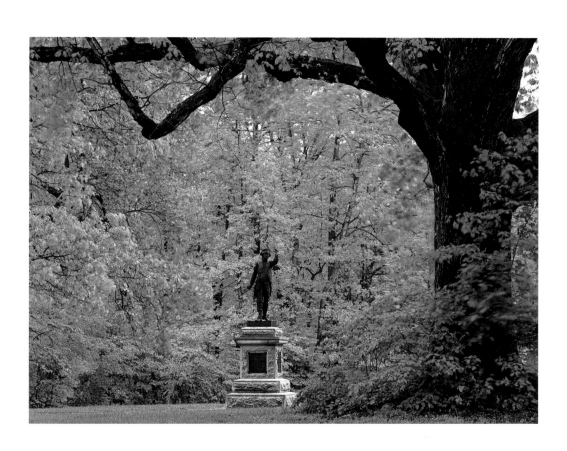

ABOVE: The figure of Major Joseph Winston waving his troops into war is one of twenty-eight monuments in the 220-acre Guilford Courthouse National Military Park, which commemorates the 1781 Revolutionary War battle that took place there. LAURENCE PARENT

LEFT: This equestrian statue of Major General Nathanael Greene honors the man who led the American forces at the Battle of Guilford Courthouse. Nearby, a statue of a laurel-crowned female figure holds two palm branches and a shield decorated with an eagle and thirteen stars. LAURENCE PARENT

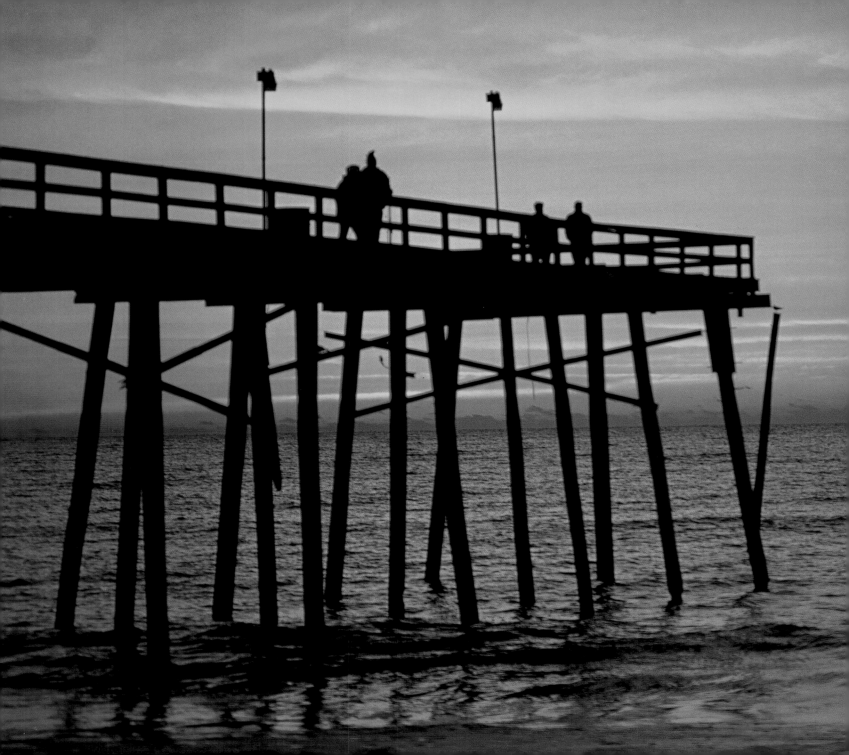

Visitors stand on Johnnie Mercer's Fishing Pier to watch the sunset redden the Atlantic Ocean. Located on the Wilmington beach, the pier was rebuilt in 2002 after being destroyed by a series of hurricanes in 1996. JIM HARGAN

RIGHT: The 1,243-foot Linn Cove Viaduct, the world's most complicated concrete bridge, was built at Grandfather Mountain on the Blue Ridge Parkway in 1983. JIM HARGAN

BELOW: From the portion of the Cherokee Reservation known as "the 3,200-acre tract," you can view the rich carpet of some of nearly 100 species of trees in 800-square-mile Great Smoky Mountains National Park. JIM HARGAN

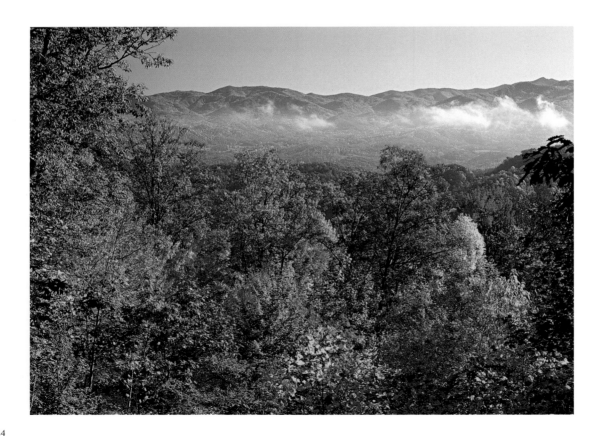

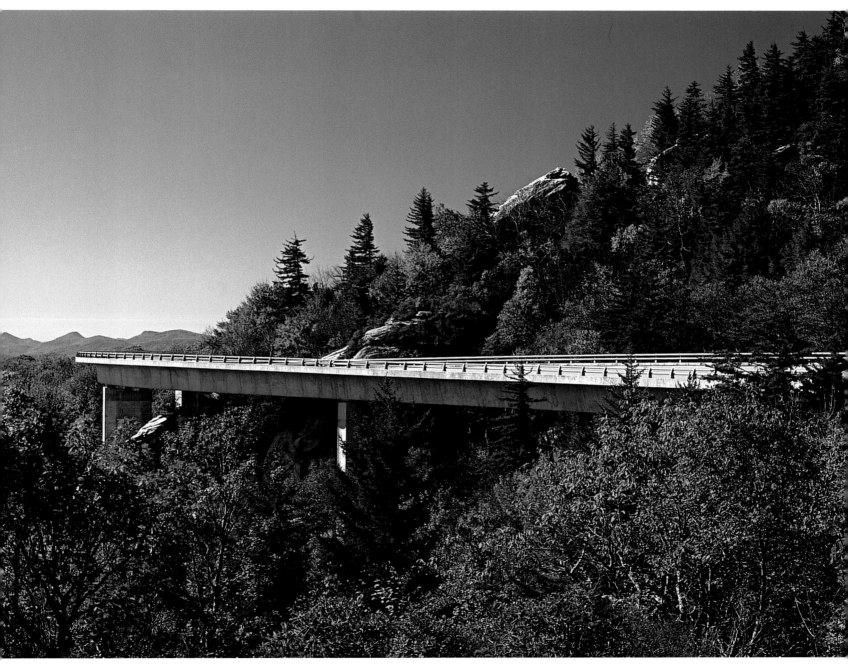

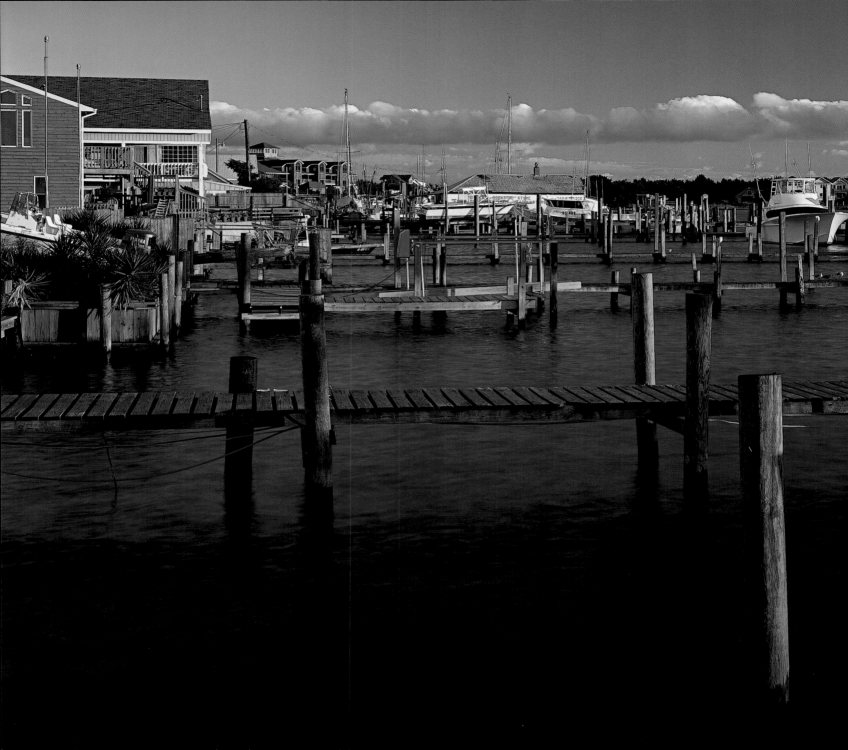

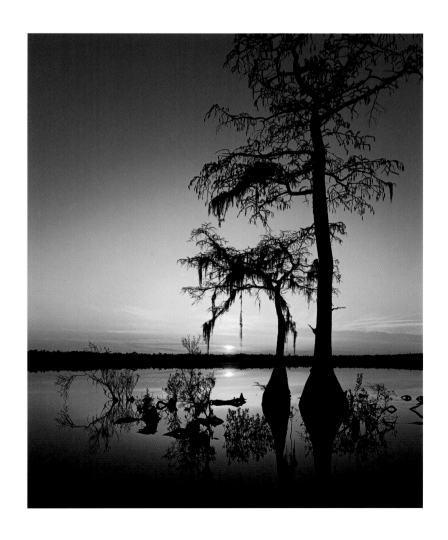

LEFT: Bald cypresses
are etched against
the reddening sky
at 2,208-acre Jones
Lake State Park.
LAURENCE PARENT

FAR LEFT: The Silver
Lake Harbor is on
Ocracoke Island, a
spot that is popular
with boaters because
it is one of the only
settled portions
of the Outer Banks
accessible by water.
LAURENCE PARENT

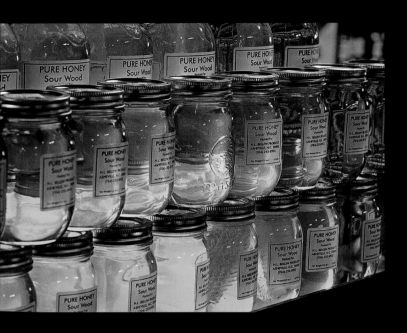

ABOVE: Locally produced sourwood honey is displayed on the shelves of the Mast General Store, which has been providing goods to the townspeople of Valle Crucis in Watauga Country since 1883. JIM HARGAN

RIGHT: Piles of newly harvested tomatoes, beans, and cabbage are displayed at the Shuler's Produce Stand in Bryson City in the Great Smoky Mountains. JIM HARGAN

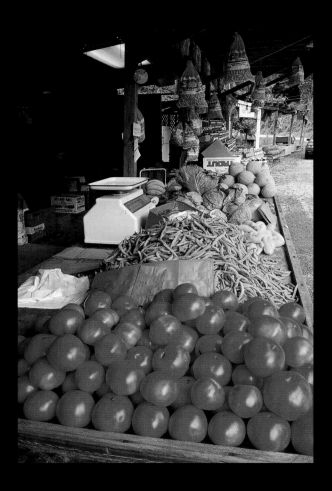

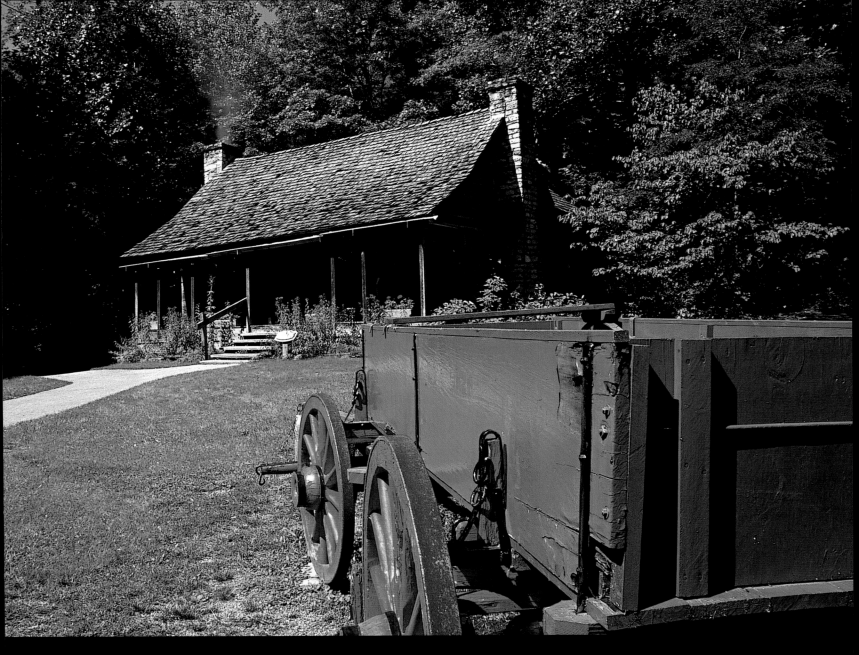

ABOVE: **A wagon sits in front of the restored log cabin at the Cradle of Forestry in the Pisgah National Forest, a National Historic Site commemorating the beginning of forestry conservation in the United States.** JIM HARGAN

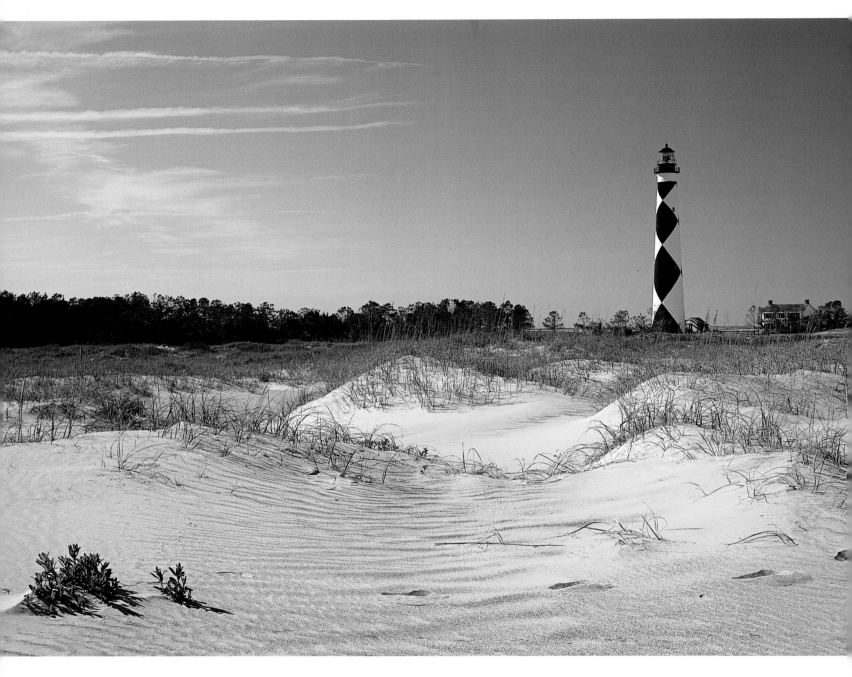

LEFT: The Cape Lookout Lighthouse and lightkeeper's cottage overlooks the dunes at Cape Lookout National Seashore, a fifty-six-mile-long section of the Outer Banks. JIM HARGAN

BELOW: Towering above the Cape Hatteras National Seashore at 208 feet, the Cape Hatteras Lighthouse is the tallest lighthouse in the nation and a symbol of North Carolina. LAURENCE PARENT

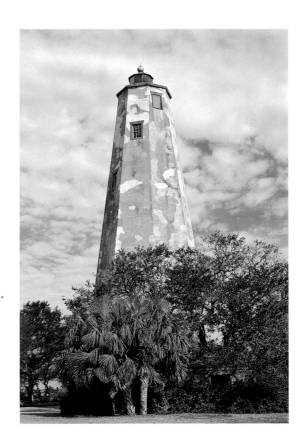

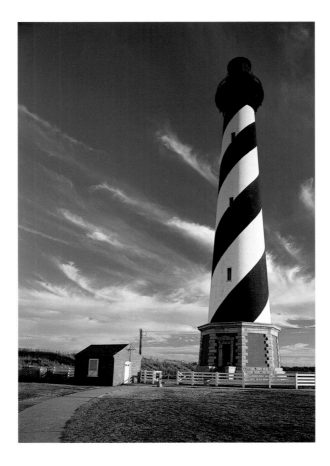

ABOVE: Old Baldy, built in 1817, is North Carolina's oldest standing lighthouse. The brick caretaker's building at its base is shaded by palm and oak trees. JIM HARGAN

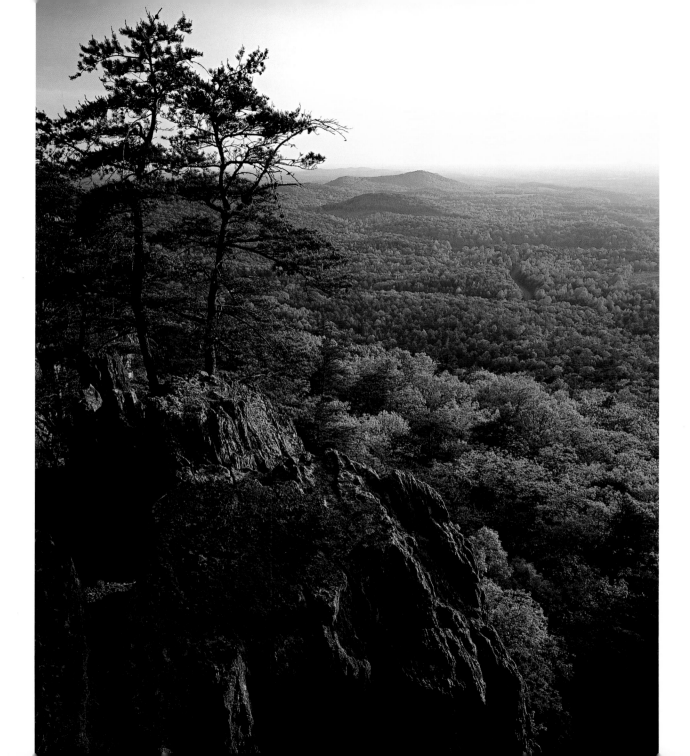

FACING PAGE: At 1,625 feet in elevation, the sheer 150-foot cliffs of Kings Pinnacle at Crowders Mountain State Park provide a dramatic foreground to the lush hardwood forests below. LAURENCE PARENT

BELOW: The historic Stewart Cabin is found in the Nantahala National Forest. Nantahala means "Land of the Noonday Sun" because sunlight does not reach the bottom of the steep gorges until the middle of the day. LAURENCE PARENT

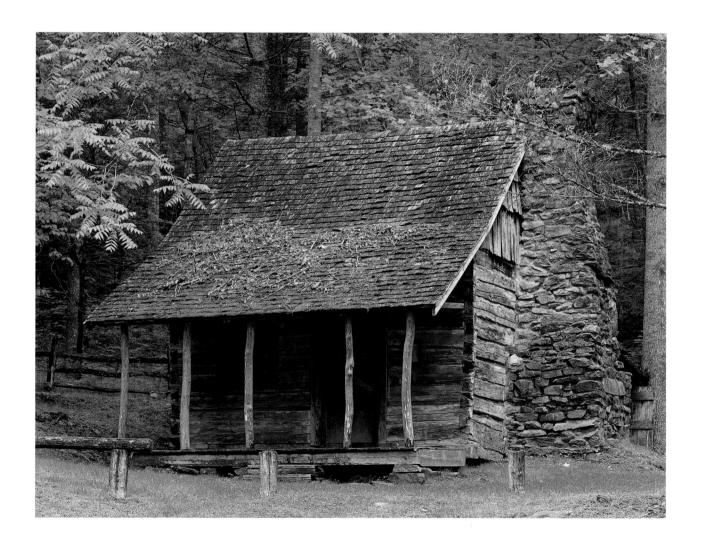

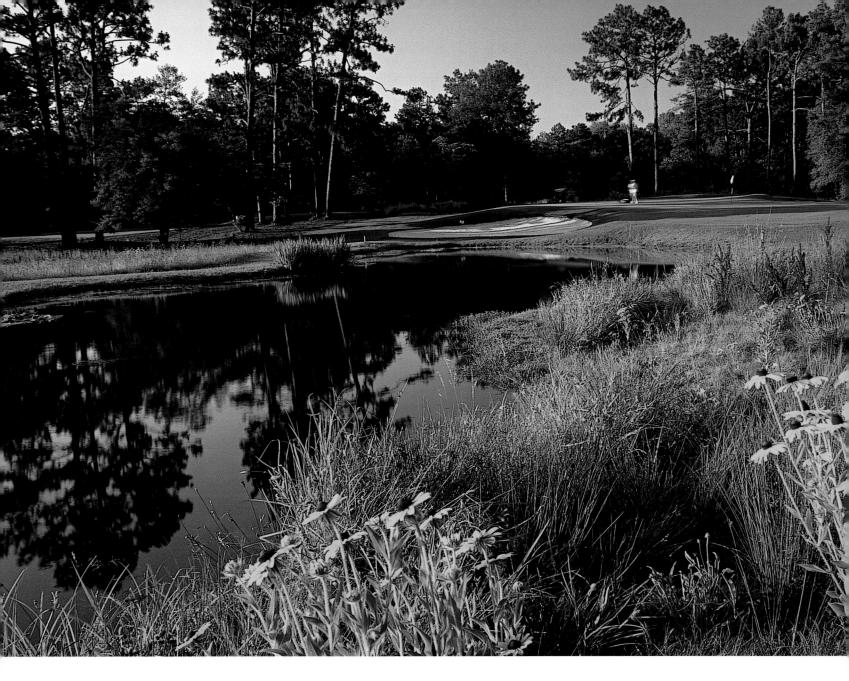

ABOVE: At the eighteen-hole Pine Needles Golf Club in Pinehurst, golfers tee-off on fairways surrounded by lush forest. JIM HARGAN

BELOW: The topiary sculpture *Putter Boy* stands in front of the clubhouse at Pinehurst Resort, built in 1895. JIM HARGAN

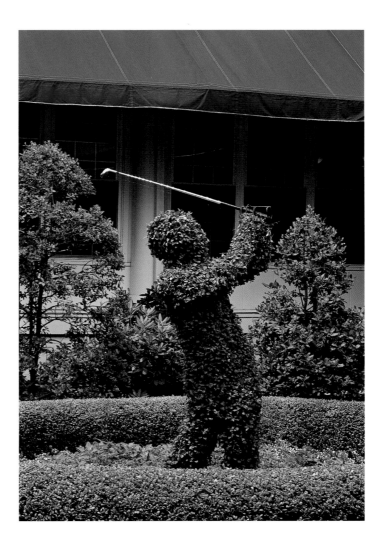

BELOW: The 115-foot Memorial Bell Tower on the North Carolina State University campus in Raleigh contains 1,400 tons of stone and was finished in 1937. JIM HARGAN

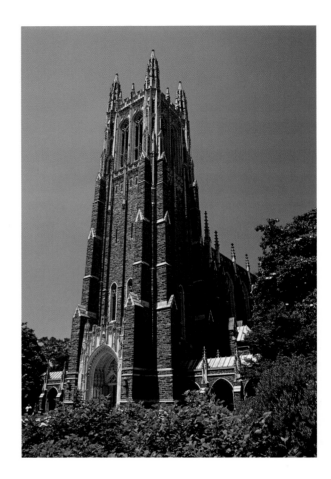

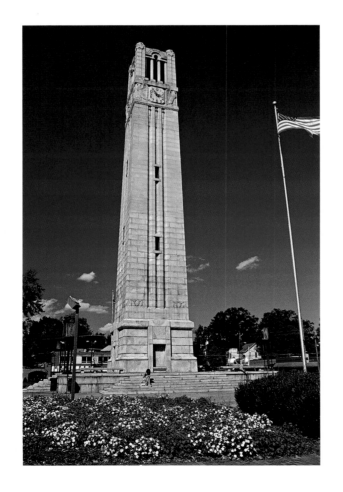

ABOVE: The 210-foot main tower of the Duke University Chapel was built from 1930 to 1935 and features three pipe organs and a fifty-bell carillon. JIM HARGAN

FACING PAGE: The statue of Ensign Worth Bagley, the only naval officer killed during the Spanish American War, stands in front of the granite North Carolina Capitol. LAURENCE PARENT

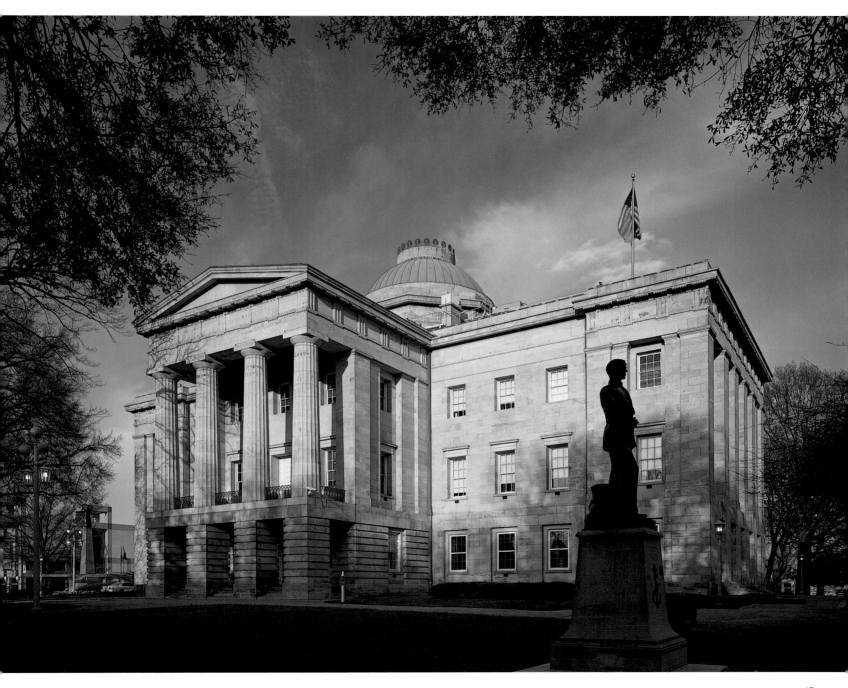

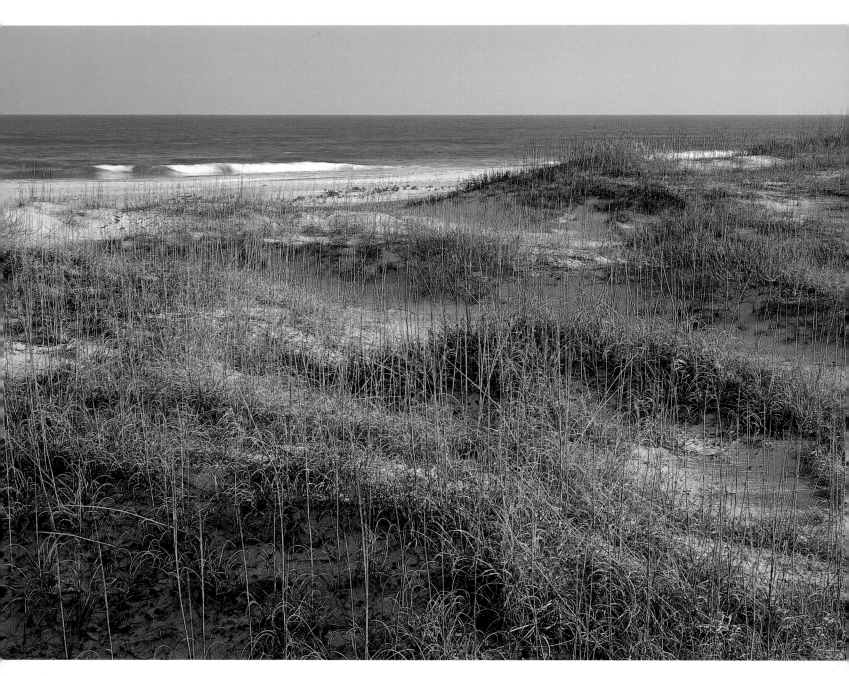

FACING PAGE: The oat grass–covered dunes fringe the beach at Core Banks, a natural, low-lying barrier island at Cape Lookout National Seashore. LAURENCE PARENT

BELOW: A sun-washed view of West Beach on Bald Head Island, which features fourteen miles of beaches. JIM HARGAN

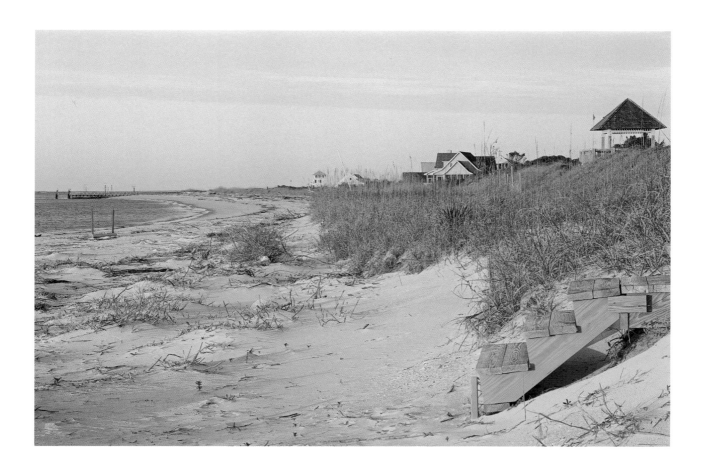

FACING PAGE: This historic rangers' cabin was part of the 1898 Biltmore Forest School. Started by George W. Vanderbilt, the school was the first to promote sustainable forest management in the United States. LAURENCE PARENT

BELOW: These deep green woods and waters are found in Nags Head Woods Ecological Preserve. Considered to be one of the finest examples of a mid-Atlantic maritime forest, the area sports pines and hardwoods up to 500 years old. LAURENCE PARENT

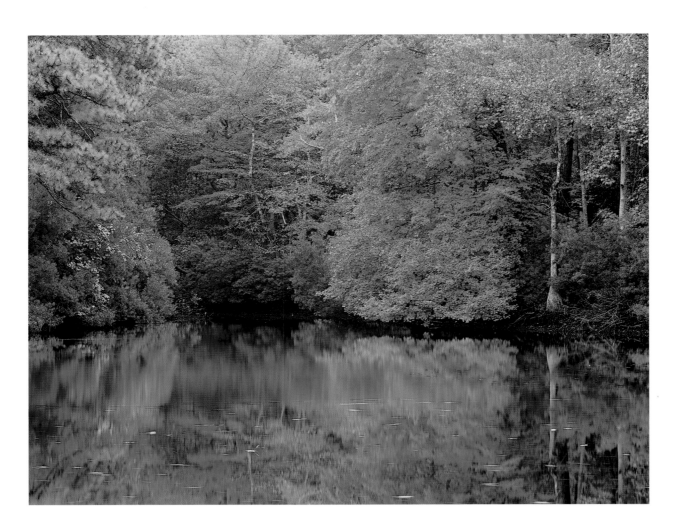

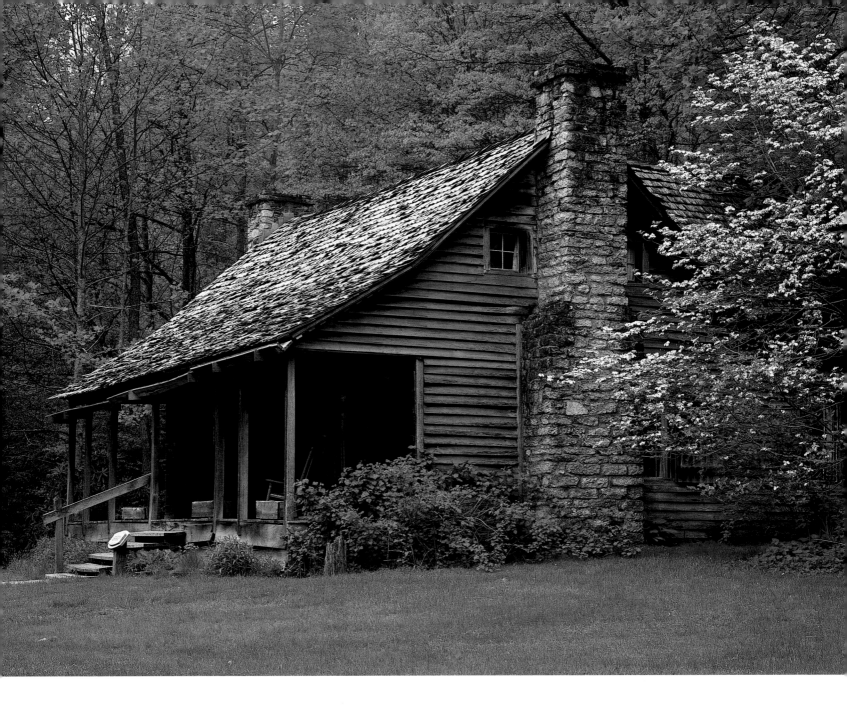

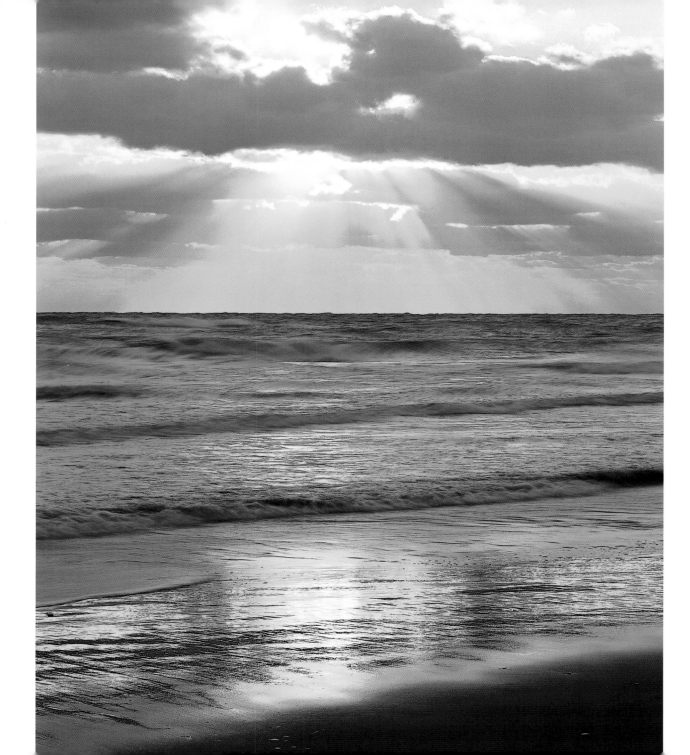

FACING PAGE: Sunrise washes Coquina Beach in yellows and reds. Nearby lie the remains of the *Laura A. Barnes,* which was shipwrecked in 1921. LAURENCE PARENT

BELOW: Boats harbored in Beaufort, a town in an area that was discovered by the Spanish in 1514 and charted by the British in 1711. LAURENCE PARENT

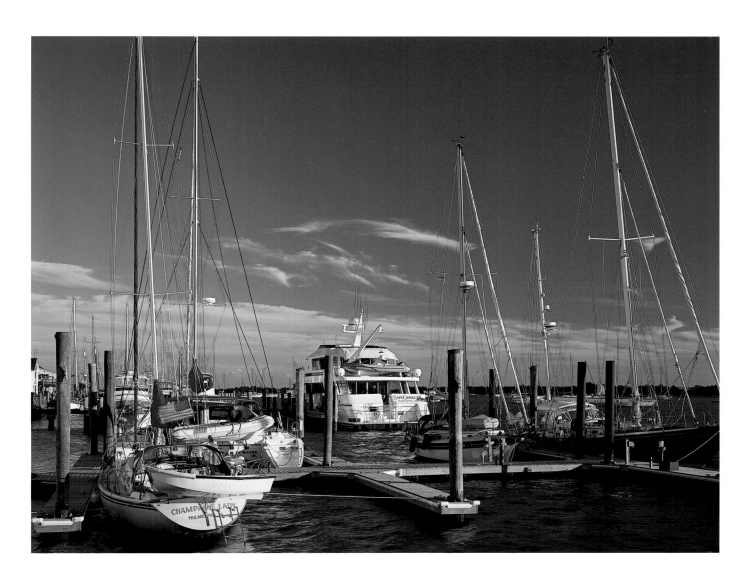

FACING PAGE: Spring-blooming mountain laurel adorns Kings
Pinnacle in Crowders Mountain State Park. LAURENCE PARENT

RIGHT: A delicate pink lady's slipper orchid is a sign of spring
in the Glen Falls area of the Nantahala National Forest.
LAURENCE PARENT

BELOW: The pink and white blossoms of large-flowered trillium
at the 4,750-foot Soco Gap Overlook along the Blue Ridge
Parkway. JIM HARGAN

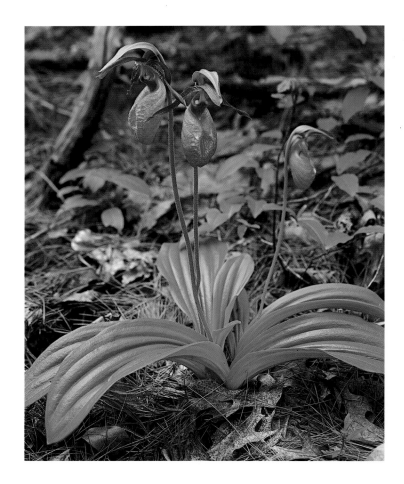

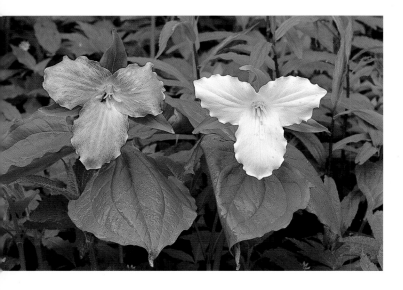

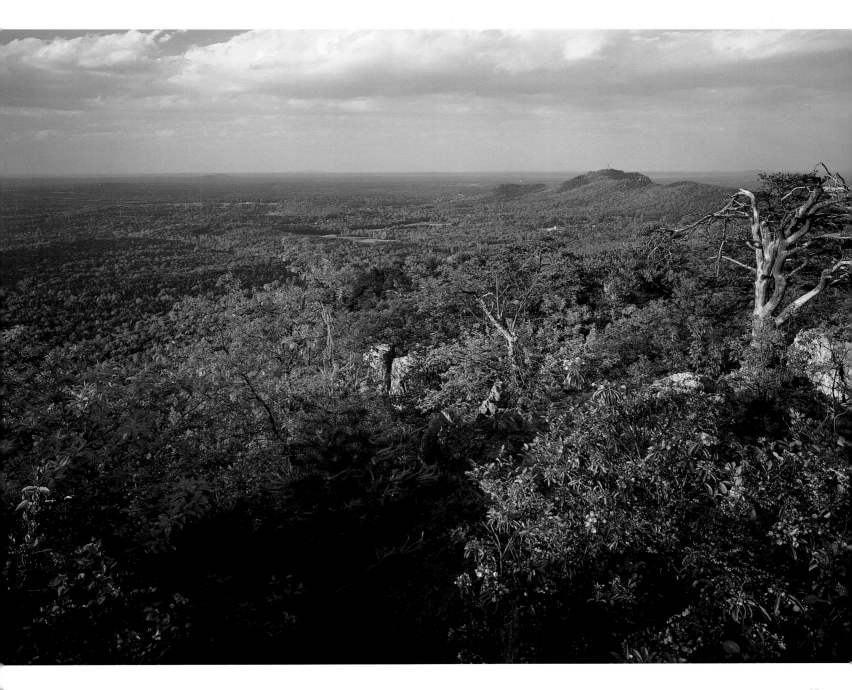

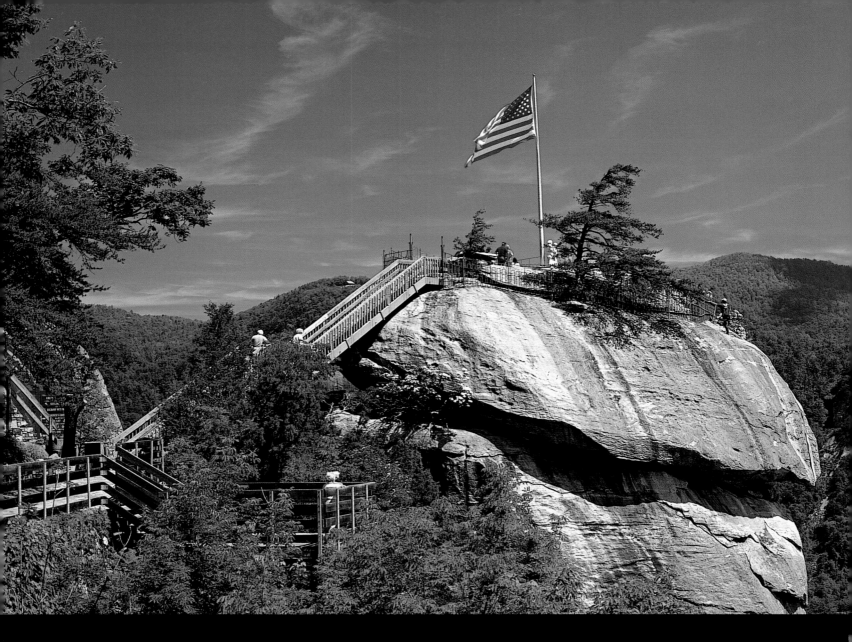

ABOVE: **Rock climbers secure their ropes to the Chimney, a 315-foot monolith that is the highlight of Chimney Rock Park, southeast of Asheville.** JIM HARGAN

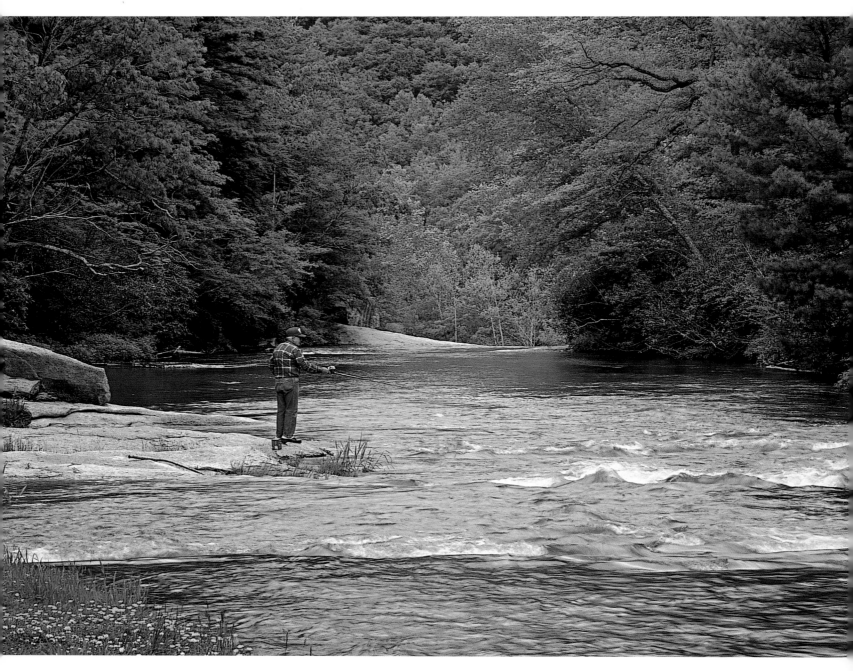

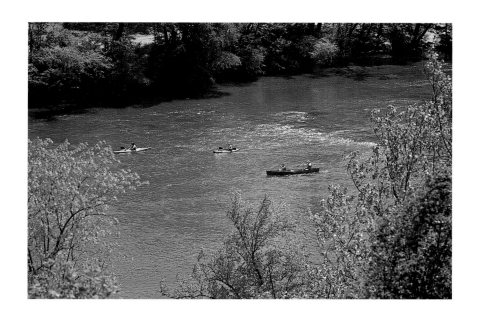

ABOVE: Canoeists, kayakers, and rowers on the French Broad River that flows 210 miles from North Carolina into Tennessee. LAURENCE PARENT

RIGHT: A kayaker negotiates the white water of the Nantahala River. Each year, nearly 160,000 boaters float the Class II- and Class-III rapids that have names such as Patton's Run and Tumble Dry. LAURENCE PARENT

LEFT: An angler fishes above Elk River Falls in Pisgah National Forest, an area that is popular with anglers looking for rainbow, brown, and brook trout. JIM HARGAN

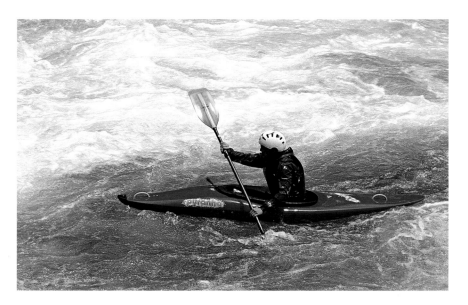

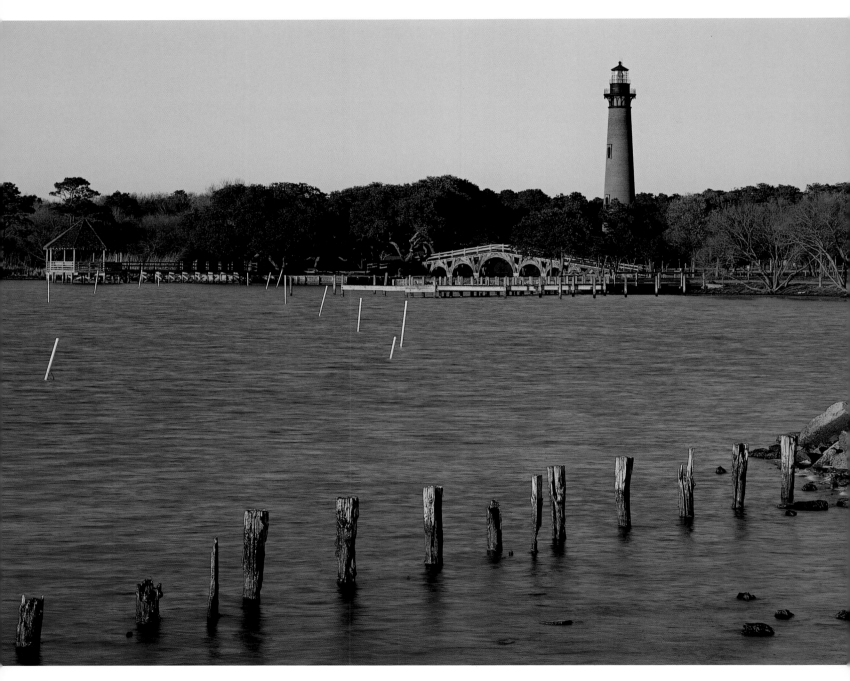

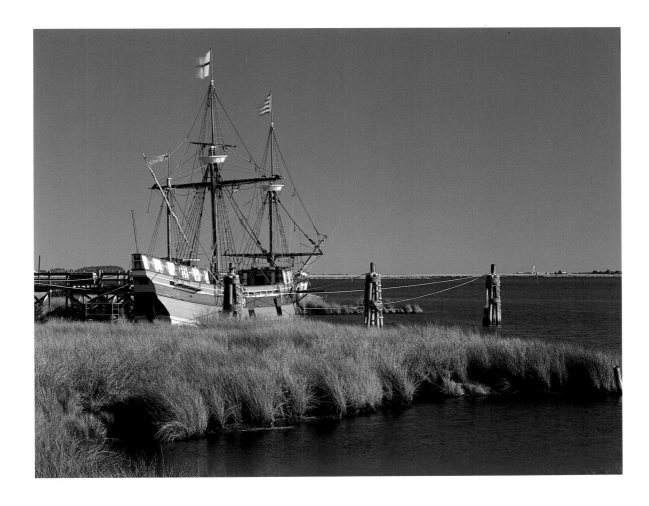

ABOVE: The *Elizabeth II*, anchored at Manteo on Roanoke Island, is named after one of Sir Walter Raleigh's seven ships that brought British colonists to Roanoke in 1587. LAURENCE PARENT

FACING PAGE: Visitors can climb the more than 200 stairs of 162-foot Currituck Beach Lighthouse, built in 1875, for views of the Currituck Sound. LAURENCE PARENT

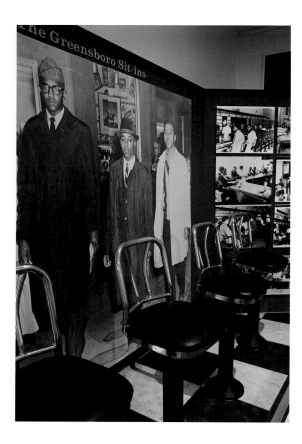

ABOVE: Greensboro Historical Museum display of the Woolworth's lunch counter where four A & C State University freshman launched the Greensboro sit-ins on February 1, 1960. In just two months, the sit-ins spread to fifty-four cities in nine states. JIM HARGAN

RIGHT: Hang gliders take to the air in the Kitty Hawk area of 414-acre Jockey's Ridge State Park that features the tallest active sand dunes in the eastern United States. JIM HARGAN

BELOW: This historic marker in front of the old Greensboro Woolworth's building commemorates the Greensboro Four—Joe McNeil, Ezell Blair, Jr., Franklin McCain, and David Richmond. JIM HARGAN

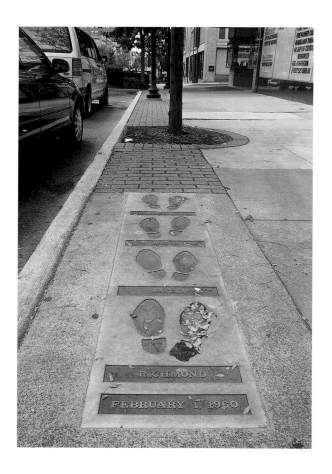

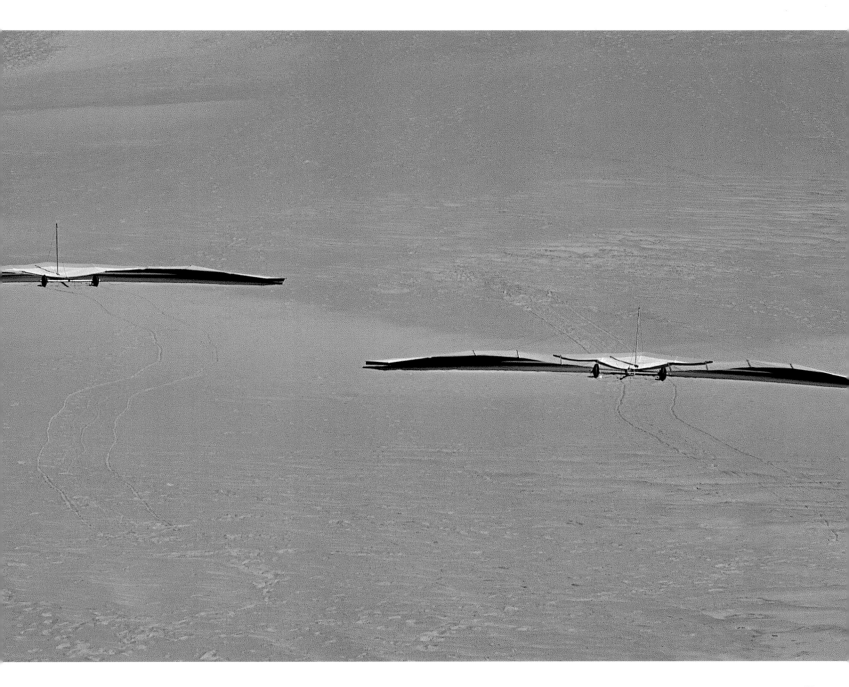

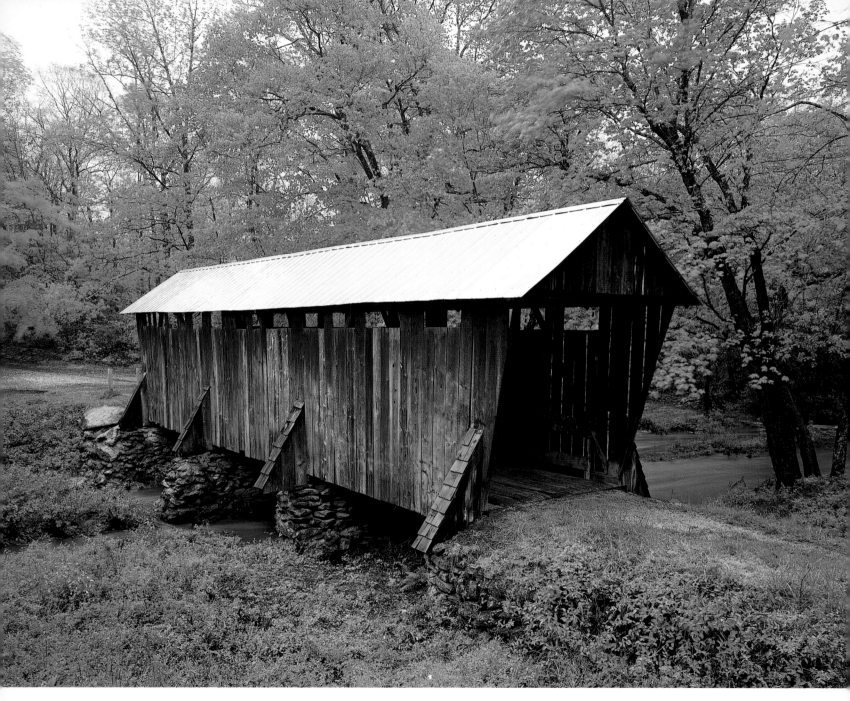

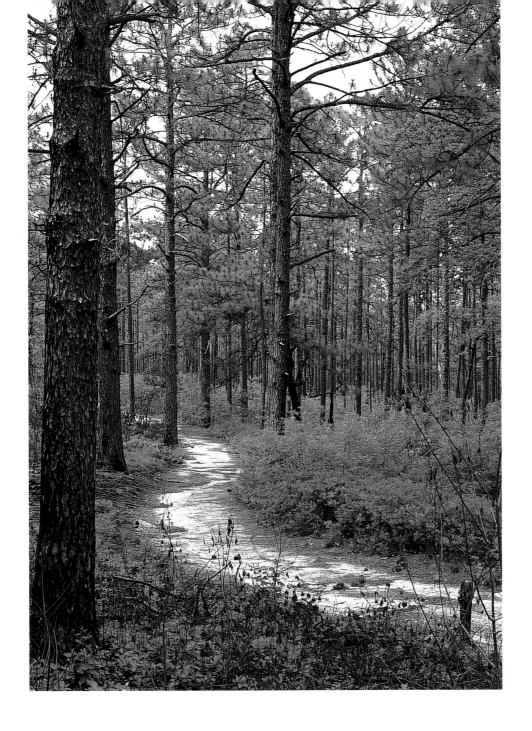

LEFT: A hiking trail winds through the longleaf pine forest in the 898-acre Weymouth Woods-Sandhills Nature Preserve. Because longleaf pine trees depend on fire to survive, controlled burns are conducted in this area. JIM HARGAN

FACING PAGE: The 1910 Pisgah Covered Bridge in Randolph County is one of only two covered bridges remaining in North Carolina. LAURENCE PARENT

BELOW: Stacks of drying brightleaf tobacco, a $600 million crop in North Carolina, cure in Smith's Brightleaf Tobacco Warehouse in Farmville. JIM HARGAN

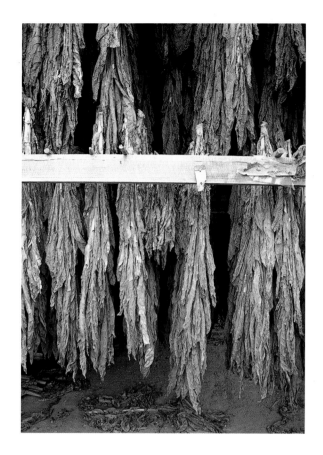

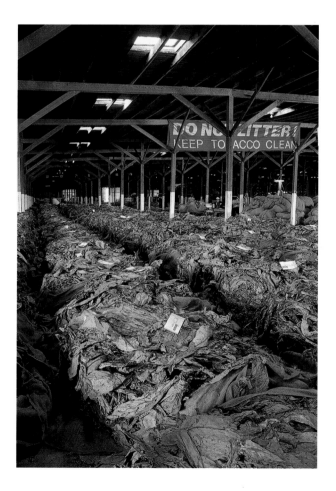

ABOVE: In a tobacco barn in Yancey County, tobacco leaves are hung to dry—a familiar sight in North Carolina, the nation's top tobacco producer. LAURENCE PARENT

FACING PAGE: The yellow of drying tobacco leaves is a colorful contrast to this bright red barn in the Possum Trot community located in the Upper Cane River area of Yancey County. JIM HARGAN

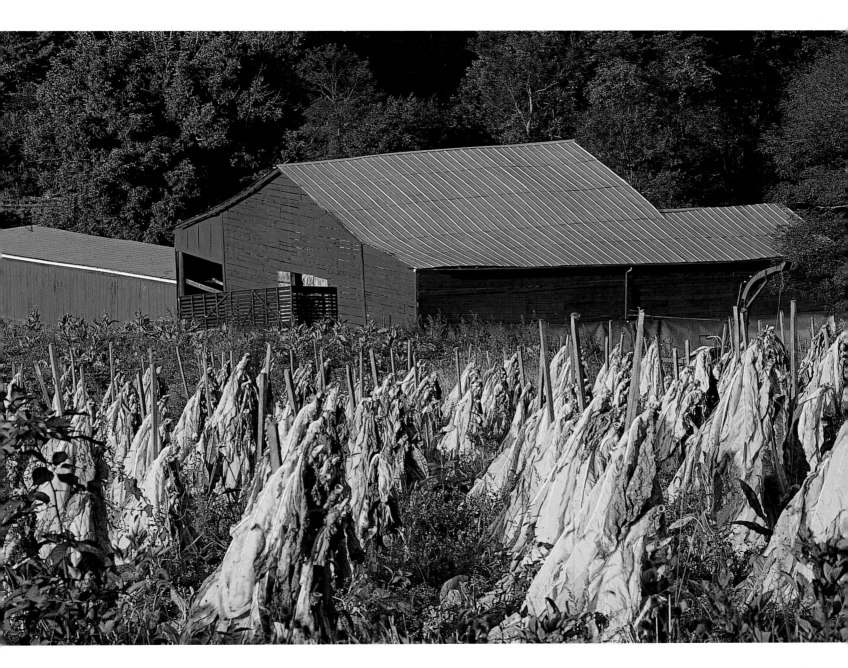

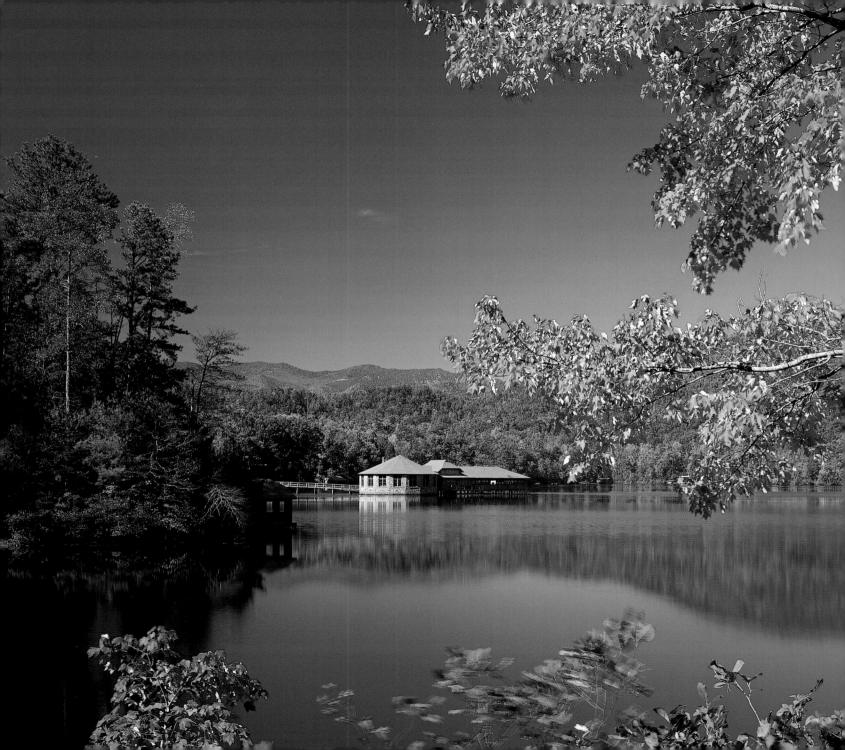

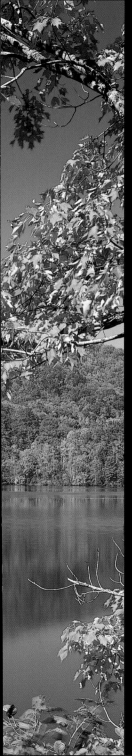

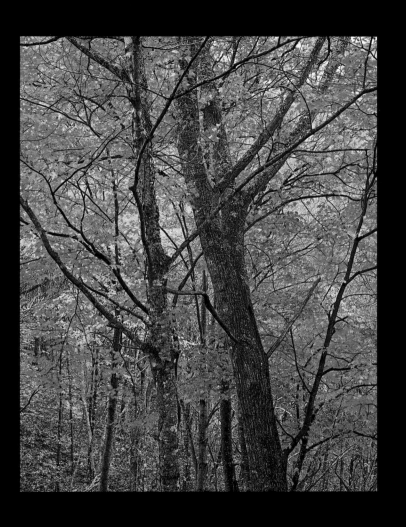

LEFT: Orange-leafed maples border the thirty-five-mile Heintooga-Round Bottom Road in Great Smoky Mountains National Park.
LAURENCE PARENT

FAR LEFT: Fall reds and yellows surround the stone building that once housed a casino at Lake Tahoma in the Blue Ridge Mountains
LAURENCE PARENT

RIGHT: From the Cowee Mountain Overlook on the Blue Ridge Parkway, ridge after ridge of the Cowee Mountains disappear into the mist. JIM HARGAN

BELOW: Sunset reddens the horizon over the soybean fields near Contentea Creek, which flows into the Neuse River. JIM HARGAN

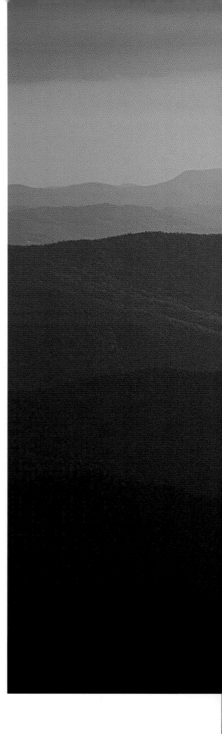

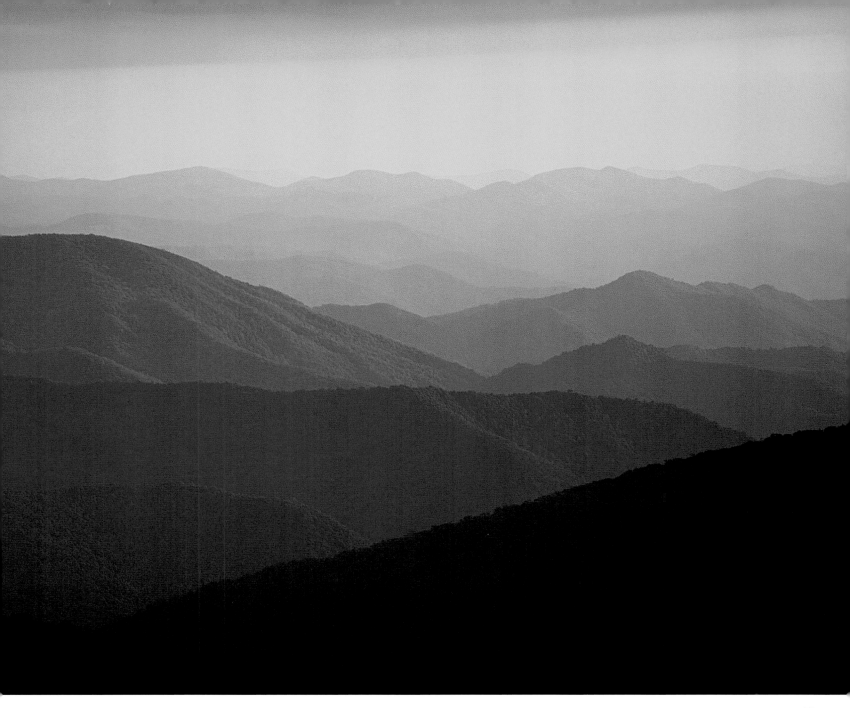

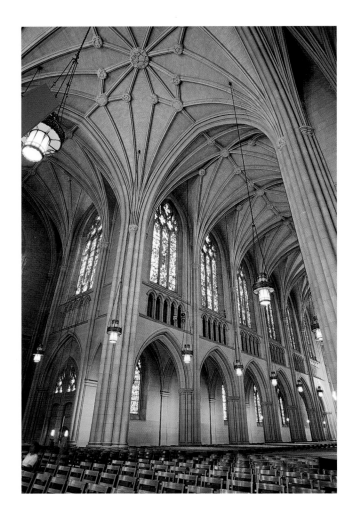

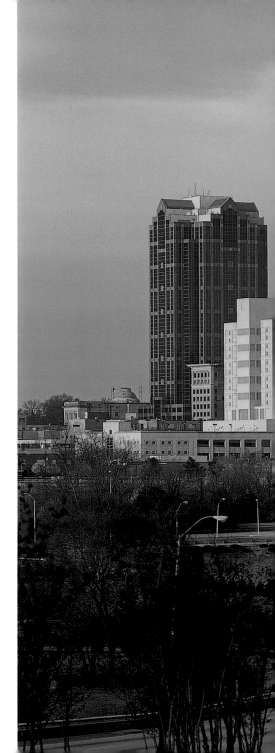

ABOVE: The Duke University Chapel, with its neo-Gothic pointed arches and ribbed vaults, seats about 1,600 people and features seventy-seven stained-glass windows. JIM HARGAN

RIGHT: The skyline of downtown Raleigh, selected as North Carolina's capital in 1788, is now a bustling center of politics, culture, trade, and industry. LAURENCE PARENT

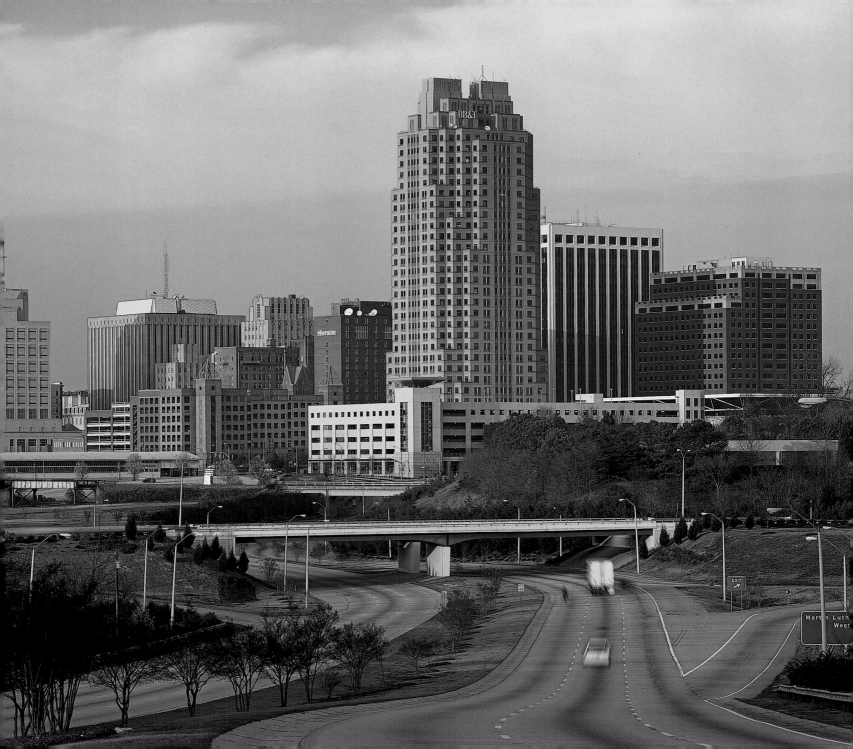

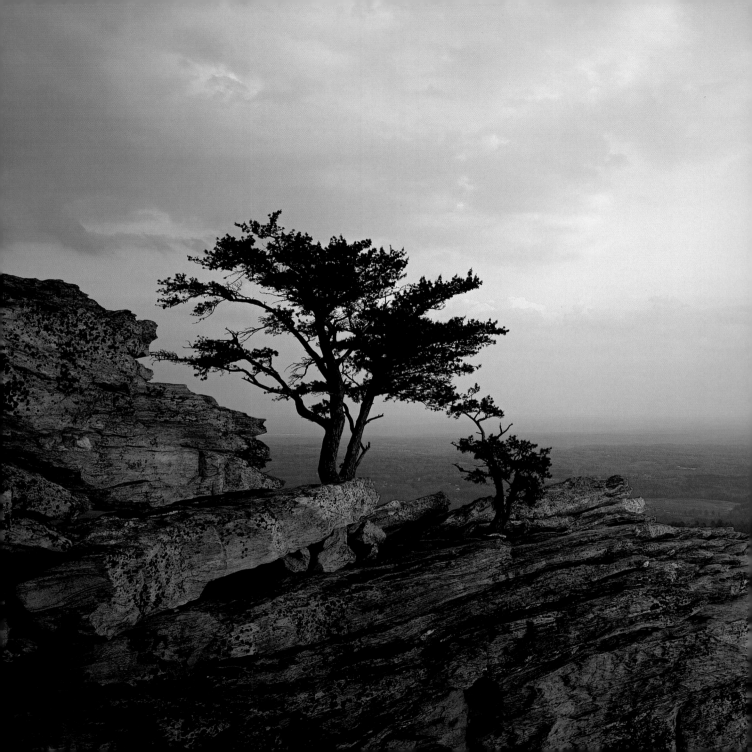

Hanging Rock, one of several ridges of quartzite rock in Hanging Rock State Park, is located in the Sauratown Mountains. LAURENCE PARENT

RIGHT: Mouse Creek Falls drops thirty-five feet through the lush forests of Great Smoky Mountains National Park. LAURENCE PARENT

FACING PAGE: The Carl Sandburg Home National Historic Site features the 1945 home of the Pulitzer prize–winning poet, biographer, and newspaper columnist, as well as the home of the Connemara Farms goat herd. LAURENCE PARENT

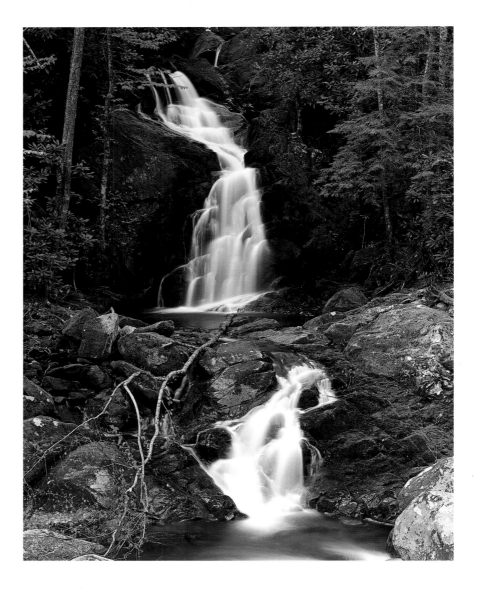

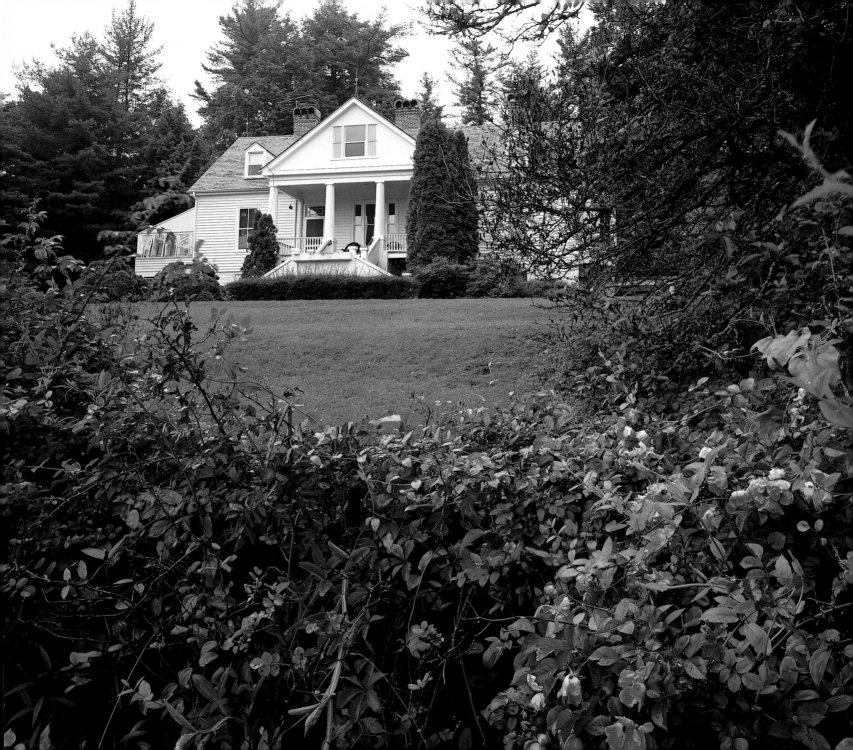

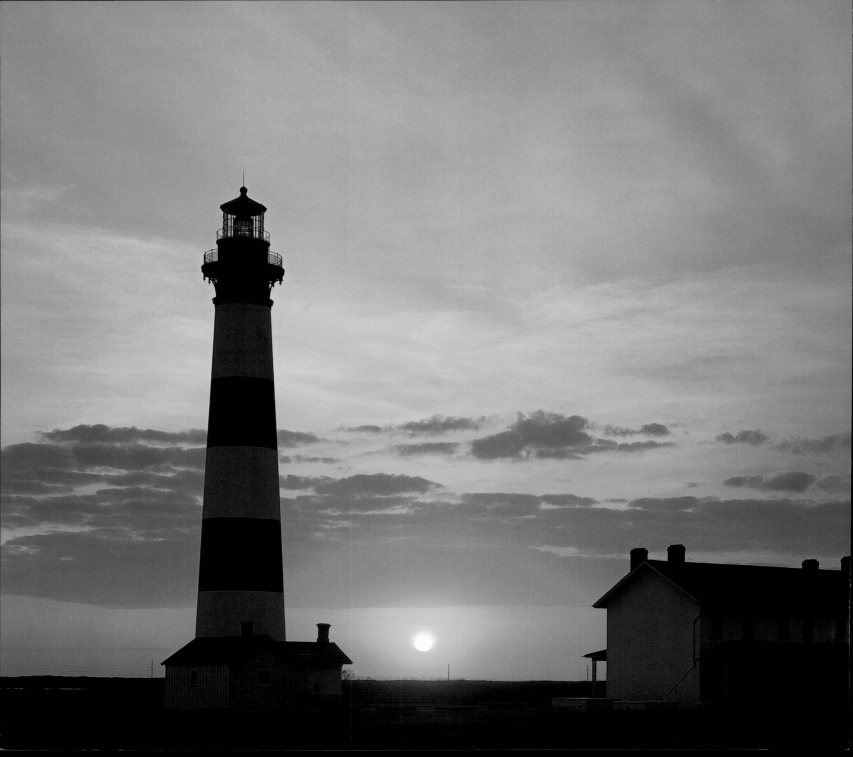

LEFT: Silhouetted at dawn, the 156-foot Bodie Island Lighthouse on the Cape Hatteras National Seashore is actually the third lighthouse built in this area—the first one was torn down and its replacement was blown up during the Civil War. LAURENCE PARENT

BELOW: A small fishing boat is docked on the sunset-hued water of Albemarle Sound, on Hertford Beach. JIM HARGAN

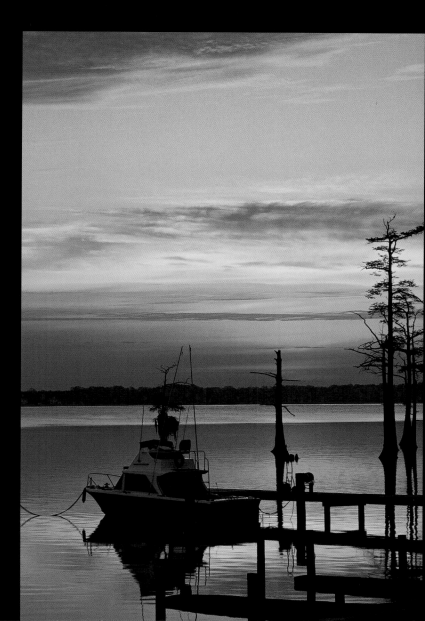

Jim Hargan

Jim Hargan is a professional travel writer and photographer. He is the sole photographer for *Compass American Guide to North Carolina* and is the author and photographer of *The Blue Ridge and Smoky Mountains: An Explorer's Guide* and *The Shenandoah Valley and The Mountains of the Virginias: An Explorer's Guide*, both published by Countryman Press. His work has also appeared in dozens of other books and periodicals, including the *New York Times*, *Blue Ridge Country*, the *Atlanta Journal*, *Field and Stream*, and many others. His numbered and signed art prints are purchased by businesses and private collectors. Jim and his wife live near Asheville, North Carolina.

Laurence Parent

Laurence Parent was born and raised in New Mexico. After receiving a petroleum engineering degree at the University of Texas at Austin in 1981, he practiced engineering for six years before becoming a full-time freelance photographer and writer specializing in landscape, travel, and nature subjects. He was drawn to the profession by a love of the outdoors and a desire to work for himself.

Laurence specializes in 4x5 landscape and 35mm outdoor sports images and has stock from fifty-two states and provinces. His photos appear in Sierra Club, Audubon, Kodak, BrownTrout, Avalanche, Graphic Arts Center, and Westcliffe calendars, just to name a few. His writing and photo credits include *National Geographic Traveler*, *Men's Journal*, *Outside*, *Backpacker*, *Sierra*, *Natural History*, *National Parks*, *Newsweek*, *Arizona Highways*, *Travel & Leisure*, and the *New York Times*. He contributes regularly to regional publications such as *Texas Highways*, *Texas Monthly*, *New Mexico Magazine*, and *Texas Parks & Wildlife*. Other work includes posters, advertising, museum exhibits, postcards, and brochures. Laurence has done thirty books with more than fifteen different publishers, including *New Mexico Impressions* (Farcountry Press).

He makes his home in the Austin, Texas area with his wife Patricia and two children.